ACTON COLLECTION SERIES

1

NYU Florence, Villa La Pietra
via Bolognese 120, 50139 Florence
https://lapietra.nyu.edu/

The titles in the series are subject to double-blind peer review

Published by
Officina Libraria
via dei Villini 10, 00161 Rome
www.officinalibraria.net

Art director
Paola Gallerani

Press Office
Luana Solla

Color separation
Premani srl, Pantigliate (Milan)

Printing
Esperia, Lavis (Trento)

isbn: 978-88-3367-078-2

The digital versions of this book in English and Italian
are available on lapietra.nyu.edu and Torrossa.com.

NYU | FLORENCE

Mauro Mussolin

SIXTUS IV AND THE BASSO DELLA ROVERE D'ARAGONA OVERDOOR

Architecture and Sculpture in Renaissance Savona

OFFICINA
LIBRARIA

To my friend Clara Altavista

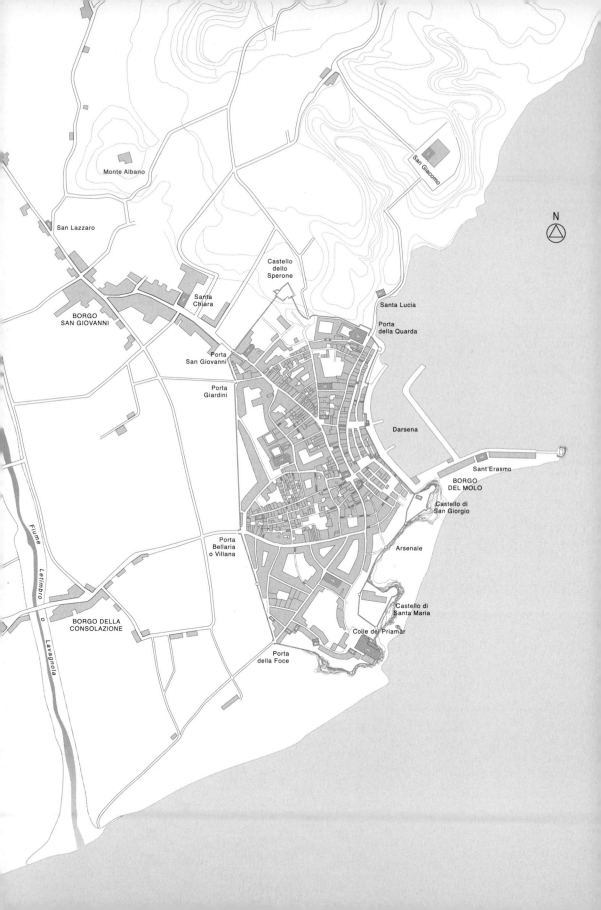

Monte Albano

San Giacomo

San Lazzaro

N

Castello
dello
Sperone

Santa
Chiara

Santa Lucia

BORGO
SAN GIOVANNI

Porta
della Quarda

Porta
San Giovanni

Porta
Giardini

Darsena

Sant'Erasmo

BORGO
DEL MOLO

Castello di
San Giorgio

Fiume

Letimbro

o

Lavagnola

Porta
Bellaria
o Villana

Arsenale

BORGO DELLA
CONSOLAZIONE

Castello di
Santa Maria

Colle del Priamar

Porta
della Foce

Table of Contents

9 Editor's Foreword

13 "SVB VMBRA TVA"

15 "Fiori di blasoneria"

26 "Familia De Ruvere olim Basso"

27 "Antonio Basso Ruvere de Aragonio"

32 "La casagrande del detto Antonio Della Rovere"

43 "Marble doorframe found in Savona:" a Boston interlude

53 "Magistri antelami" and "pichapietra"

58 "Il bassorilievo in marmo, che vedesi marcato in rosso"

64 Genealogy of the Della Rovere

66 Notes

78 Bibliography

95 Photograph Credits

Editor's Foreword

It is with great pleasure that we inaugurate the Acton Collection Series with this volume by Mauro Mussolin on the Basso Della Rovere d'Aragona Overdoor. This fifteenth-century marble relief is one of the treasures of the art collection assembled by Hortense Mitchell and Arthur Acton to decorate their home at Villa La Pietra. Villa La Pietra became the seat of New York University Florence following the donation of the collection to the university by their son, Sir Harold Acton, in 1994. This first volume thus offers a fitting tribute to his generosity on the twenty-fifth anniversary of his gift. The purpose of this occasional series is to offer fresh scholarship on objects in the collection by focusing on individual works, or related groups of works, to further scholarly understanding of these and broaden public awareness of the range and quality of the works collected by the Acton family. These short monographs present distinctive approaches to the practice of art history and are intended to highlight the exemplary methodologies of the scholars featured in the series as paradigms for students and colleagues, in addition to making it possible to discover little known gems of the Acton Collection.

Bruce Edelstein
Coordinator for Graduate Programs
and Advanced Research, NYU Florence

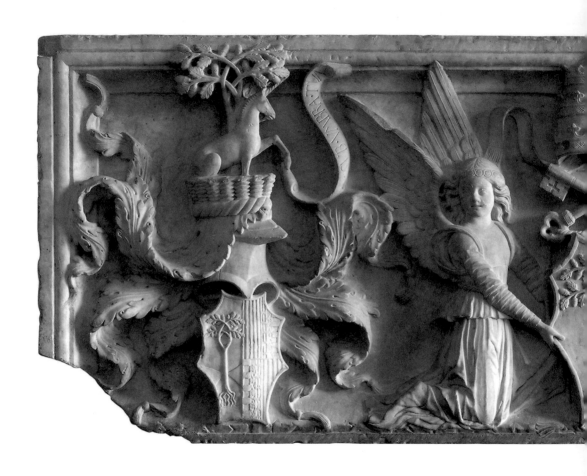

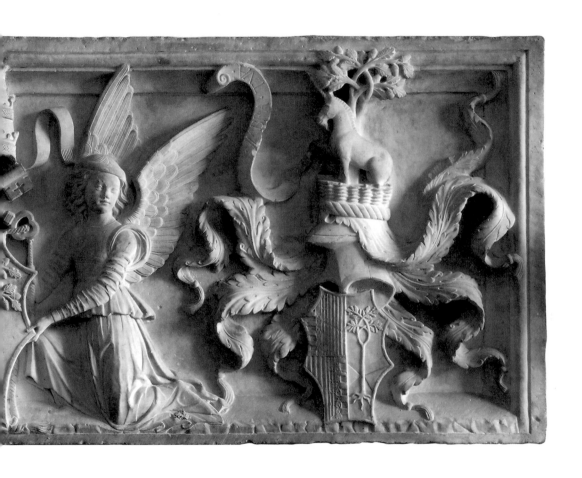

Fig. 1 Basso Della Rovere d'Aragona overdoor, marble, 1479,
Acton Collection, Villa La Pietra, Florence.

Coats-of-arms are like old coins: they are good if they are real, they count if they are rare, they get spent if they are valuable.

Heraldry has its alchemists. They look for gold where there is none. They peddle boasts, invent fairy tales, and conjure ancestors: impostors, or charlatans!

But heraldry, when studied for history and not for ambition, can give valid aid to the numismatist, the paleographer, the antiquarian, the artist. And since I would do well to wrap this up, I will do it with a wish that heraldry, among us, does not remain in perpetual oblivion, that it is taught in the academies to painters, that it is explained with seriousness in the archive schools, where it would find its proper place, to scholars of the history of their native land.

Antonio Manno, 1876

"SVB VMBRA TVA"

A t the height of World War I, a large marble relief with a heraldic motif quietly entered the rooms of Villa La Pietra, enriching the magnificent collections of Arthur Acton and his wife Hortense Mitchell (fig. 1).[1] Just under two-and-a-half meters wide, almost one meter high, about fifteen centimeters thick, and weighing more than seven hundred kilograms, the monumental relief immediately became, and still remains, one of the most impressive works in the collection. The canting arms of the Della Rovere family are easily recognizable in the middle of the composition: an uprooted oak tree with two pairs of crossed branches laden with acorns, together with the pontifical emblems of the papal tiara and keys and, to the sides, impaled shields bearing the arms of the Basso Della Rovere (the same laden oak tree, seemingly on top of a cross of St. Andrew) and the Royal House of Naples (with the field divided into three parts, or tierced in pale, to include the arms of Aragon, Anjou, and the Kingdom of Jerusalem).[2]

The sculpture was immediately placed in the corridor on the ground floor of the villa, in the Hall to Pomario, a passageway with a fifteenth-century barrel vault that connects the center of the house with the garden on the north side of the building (fig. 2, fig. 3).[3] Now as then, this space is filled with a plethora of varied works displayed in the exquisite antiquarian taste of old Florence. Among crucifixes, colorful Madonnas, velvets, and terracottas, the monumental marble relief seems to rest on a large piece of antique furniture, but it is actually securely anchored to the wall with robust metal brackets.

Photographs were soon taken of the bas relief (henceforth, the Acton overdoor), including the one taken by the photographer Luigi Reali of Florence between the wars.[4] Another photograph of the work, in this case heavily retouched, was published in 1978 by Carlo Varaldo, one of the leading experts in Ligurian art and architecture, in the first volume of the *Corpus Inscriptionum Medii Ævi Liguriæ*. The scholar had found the image in the photographic archive of the Soprintendenza ai Beni Ambientali ed Architettonici della Liguria in Genoa. Due to the presence of the motto "SVB VMBRA TVA," he included the monumental work in the section of his volume on destroyed and lost inscribed stone plaques from Savona. While the Soprintendenza's data sheet for the relief indicated that it might have come from the destroyed Savona Cathedral, Varaldo more convincingly argued that it was from an unidentified building belonging to the Basso Della Rovere family, or a family linked to it, and, based on the work's stylistic maturity, which is quite clear in spite of the retouching of the old photograph, suggested

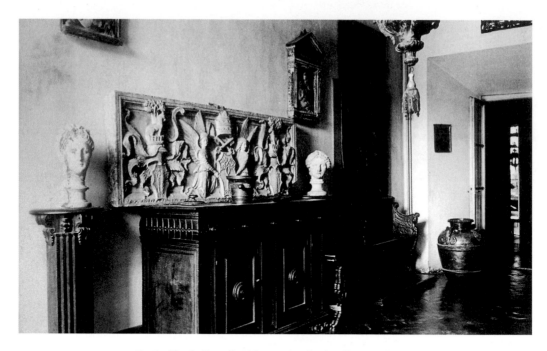

Fig. 2 North East Corridor to the Garden Pomario (photo printed in reverse), The Acton Photograph Archive, Villa La Pietra, NYU Florence.

Fig. 3 North East Corridor to the Garden Pomario, The Acton Photograph Archive, Villa La Pietra, NYU Florence.

a date during the period of Julius II.[5] When I had the opportunity to tell Varaldo that the work was in the Acton Collection, the surprise was reciprocal. For him, it was the fact of finding an important lost work. For me, it was discovering an important bibliographic reference that confirmed my hypothesis that the portal had come from Palazzo Basso Della Rovere in Piazza della Maddalena, Savona and celebrated the marriage between Antonio Basso Della Rovere and Caterina Marzano d'Aragona, which took place in 1479 under the auspices of Sixtus IV.

In spite of the dearth of research, the Acton overdoor is one of the most extraordinary and refined examples of fifteenth-century Ligurian overdoors. This type of monumental sculpture was in fact a characteristic element of early-Renaissance Ligurian architecture and common along the entire coast from Ponente to Levante. Portals with overdoors of this kind were for the most part used to decorate the entrances of the most magnificent and emblematic buildings.[6] Besides its objective artistic quality, the Acton overdoor is also of particular interest as a text: constructed in accordance with the conventions of heraldic representation, it contains a body of historical information that has made it possible to reconstruct an entirely new chapter of the Savona Renaissance in the age of the Della Rovere.

"Fiori di blasoneria"

The primary characteristic of heraldic representation is its visual expression of the terms of a social relationship that an individual, a group, or a collective has established with one's own peers. Through the study of coats-of-arms, we can thus trace a variety of public relationships that affirm the identity of the individual, the family, or the community within his or its sphere of action. It is therefore a complex system of conventional imagery conceived and structured as a shared means of communication. Since social relationships change over time and space, heraldic imagery follows these changes with the same spirit of adaptation and transformation, in the end constituting a litmus test for the represented subject's skill in political negotiation. Over time, the development of the customs of heraldic representation came to define a figurative language based on broadly accepted traditions and usages, with equally clear exceptions and rules, capable of constructing an integrated system of relational and significative signs. In precisely these cases, the study of coats-of-arms can reveal the most important chapters in the social life of an individual or group. Well beyond common marital alliances, heraldic representation emphasizes with equal effectiveness a series of otherwise elusive social and political relationships, including declaration of dynastic ascendance (such as claims over fiefs and dominions), relationships of power or dependency (recognition of sovereignty or submission), conferral of concessions or titles (including feudal investitures),

the institution of special familial ties (adoptions of various kinds and entry into family cliques), badges of rank (including honorific appointments), and recognitions of public or personal merit.[7]

To summarize, each armorial achievement is structured like a deposit of graphic operations formulated over time that ends up constituting a kind of archive of the public relationships of the represented subject, thus contributing to defining a device that records the subject's most important phases and relative political and social weight. In order to orient one's interpretation of heraldic representations and understand the most basic rules for reading a coat-of-arms, it is therefore worthwhile to remember a few principles and some of the more common conventions. Among these, it is fundamental to learn how to recognize the order of importance attributed to the various fields of the shield, respecting the topography of its constituent elements.

The first and most general of these conventions concerns the spatial hierarchies within and around the shield, where what is in the center is more important than what is on the sides, what is above prevails over what is below, and what is on the right has greater importance than what is on the left. With respect to right/left indications, it is necessary to remember a fundamental anomaly of heraldic representation. In heraldry, right and left, or dexter and sinister, are never considered with respect to the person in front of the shield, but rather with respect to the one wearing it. Therefore, what is on the heraldic right has greater importance and is seen by the viewer on the left while, conversely, what is on the heraldic left has lesser importance and is seen by the viewer on the right.

Another important convention concerns the distinction between simple arms, composite arms, and original arms. In simple arms, the shields have no interior divisions and generally belong to a single subject (an individual, family, or community). Composite arms contain multiple arms within the same coat-of-arms and thus display the union of multiple subjects, expressed in more or less complex divisions (such as those of impaled, tierced, or quartered shields). And finally, original arms, which are the original ones of a subject that, although united with others, continues to retain the most important position in the coat-of-arms (the heraldic right, in the first quarter, in the chief or an over all inescutcheon). In the frequent cases of shields with complex divisions, it is therefore critical to identify the order of importance of the individual parts and ensure that one's interpretation respects this hierarchy. When there are divisions within a division, the same rules apply, as if they were sections and subsections of a chapter in a book.[8] We shall thus attempt to interpret the meaning of the coats-of-arms in the Acton overdoor in accordance with the above conventions. We will begin our analysis with the largest armorial achievement, presented frontally, or to use the specific terminology in "majesty," proceed with the one on the heraldic right (on the viewer's left), and end with the one on the heraldic left (on the viewer's right).[9]

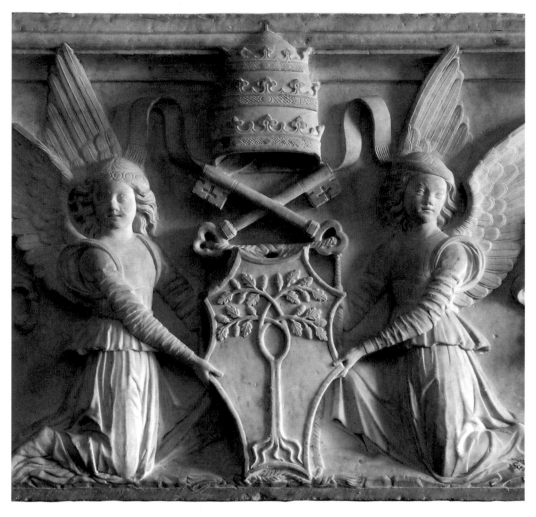

Fig. 4 Basso Della Rovere d'Aragona overdoor, detail of the
central coat-of-arms, marble, 1479, Acton Collection, Villa La
Pietra, Florence.

The larger size of the middle coat-of-arms already expresses its dominant role in the
whole composition of the relief (fig. 4). The shield has the typical horse-head shape of Italian
escutcheons and is crowned by the attributes of the highest papal authority, the keys of St. Peter
combined with the papal tiara (*triregnum*). The elegant pair of kneeling angels emphasizes the
maiestas papalis and divine origin of his authority. The shield's arms is the uprooted oak,[10]
which was adopted without significant variations by both popes of the celebrated Savona family,
Sixtus IV and Julius II.[11] But in this case, there can be no doubt that it is the shield of Sixtus
IV. Indeed, the union of the arms of the royal house of the Neapolitan Aragonese and that of
the Basso Della Rovere, displayed on the two side shields, never occurred during the papacy

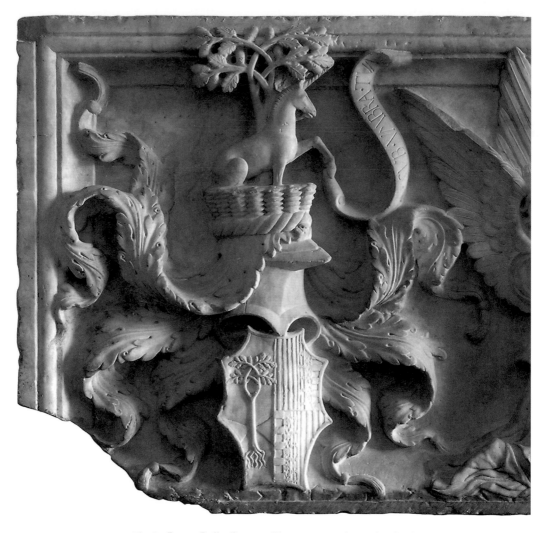

Fig. 5 Basso Della Rovere d'Aragona overdoor, detail of the coat-of-arms on the heraldic right, marble, 1479, Acton Collection, Villa La Pietra, Florence.

of Julius II (1503–1513), but happened three times during that of Sixtus IV (1471–1484). An early matrimonial alliance was established in 1472, when Leonardo della Rovere, nicknamed "il Piccinino" and already a prefect of Rome, married Joanna of Aragon, the daughter of King Ferdinand I, for which the king subsequently invested Leonardo with the rank of duke, granting him the fiefs of Arce and Sora.[12] A second alliance was made after Leonardo died in 1475, when Giovanni della Rovere, lord of Senigallia and brother of the future Julius II, inherited his cousin's prefecture and feudal titles, as well as the privilege of using the Aragonese arms in his shield.[13] The third alliance, again matrimonial, came in 1479, when Antonio Basso Della Rovere

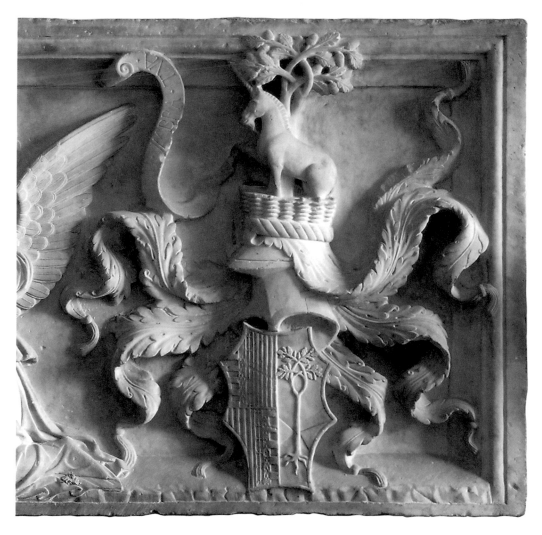

Fig. 6 Basso Della Rovere d'Aragona overdoor, detail of the coat-of-arms on the heraldic left, marble, 1479, Acton Collection, Villa La Pietra, Florence.

married Princess Caterina Marzano d'Aragona, daughter of the renowned Marino Marzano and Eleonora d'Aragona, daughter of Alfonso I, king of Naples.[14] Caterina's dowry fetched Antonio the countship of Aliano and Stigliano in Basilicata and the consequential association with the Aragonese.[15] In the side shields of the Acton overdoor, the combination of the original saltire of the Basso[16] and the Della Rovere oak excludes the possibility of referring to either of the first two unions with the house of Aragon, allowing only the last, between Antonio and Caterina. It was unfortunately a very short marriage, lasting just one year and brought to an end by Antonio's early death in 1480, followed by the return of the dowry and feudal titles.

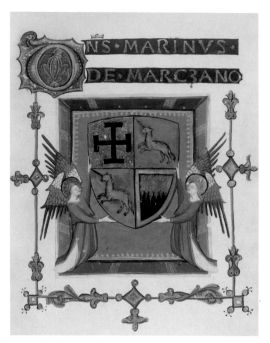

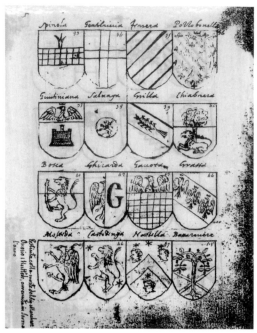

Fig. 7 Coat-of-arms of Marino Marzano, mid-15th century, in *Codice di Santa Marta*, fol. 29, Archivio di Stato di Napoli.

Fig. 8 Coat-of-arms of the "Bassarovere", in Giovanni Vincenzo Verzellino, *Armi di Famiglie Savonesi raccolte e poste insieme da Gio. Vincenzo Verzellino. 1621,* fol. 5 [copy by Giovanni Tommaso Belloro (?), known as *Stemmario,* before 1821, location unknown, from a microfilm of the Archivio di Stato di Savona].

The perfect symmetry of the side shields of the Acton overdoor highlights the groom's social rank at the time of his marriage (fig. 5, fig. 6). The slight three-quarter rotation of the tournament helmet with a "sparrow's-beak" visor confirms Antonio's noble rank as feudal lord. The composition of the tall crest is equally eloquent, its base ringed by a twisted torse from which issue seven fluttering leaf-shaped lambrequins. Above the torse, there is a wattle fence, in the middle of which stands the Della Rovere oak. A unicorn sits beneath the oak, with a front leg raised to hold up a banderole. The latter is inscribed with Antonio's personal motto, "SVB VMBRA TVA," sculpted in Roman capitals. The chimerical animal par excellence, the unicorn makes explicit reference to Antonio's noble virtues, invincible strength and, most importantly, pure loyalty to the family and the papal authority. The composition of this crest appears to be an astonishing embodiment of the withering words of August Schmarsow, according to whom the pope's relatives gathered beneath the shade of the great papal oak in hopes that its golden fruit would fall plentiful into their laps.[17] However conventional, the presence of the unicorn has a further meaning. Indeed, it is possible that the suggestion to use this animal came to Antonio

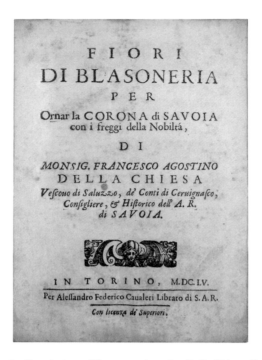

Fig. 9 Frontispiece of Francesco Agostino Della Chiesa, *Fiori
di Blasoneria per Ornar la Corona di Savoja con i freggi della
Nobiltà*, Per Alessandro Federico Caualieri libraro di S.A.R.,
Torino 1655.

through Caterina. Beyond the customary adoption of a unicorn as a symbol of purity, clearly appropriate for a new bride, the use of this mythological animal as her father's family insignia might be more significant. Marino Marzano's quartered coat-of-arms features unicorns in the second and third quarters, as we see in a magnificent illumination in the codex of the aristocratic confraternity of Santa Marta in Naples (fig. 7). Unicorns were also included in the stone coats-of-arms (now lost) decorating the small palace built by Marino in Carinola around 1450.[18]

Returning to the Acton overdoor, the first partition of the shield on the heraldic right features the arms of the Basso Della Rovere family, while the second features that of Aragon. This is exactly how the "Bassarovere" family shield is described in the unpublished armorial manuscript *Armi di Famiglie Savonesi* (fig. 8), a collection of sheets possibly copied by Giovanni Tommaso Belloro (1741–1821) from manuscripts belonging to Giovanni Vincenzo Verzellino (1562–1638).[19] And yet, looking closely, we see that the original Basso arms is not an ordinary saltire but rather a pairing of two triangles attached to the lower sides of the shield, quite far apart from one another. In heraldic terms, these triangles would be more appropriately

Fig. 10 Monument of Girolamo Basso Della Rovere, choir of
Santa Maria del Popolo, Rome, illustration from Francesco Maria
Tosi, *Raccolta di monumenti sacri e sepolcrali scolpiti in Roma*
nei secoli XV e XVI, misurati e disegnati dallo architetto cav.r
Francesco M.a Tosi ed a contorno intagliati in rame da valenti
artisti [...], V, [Rome], 1856, plate CXXXIX.

described as opposing points on the shield's lowered fess. While this reading might seem overly fussy, it is supported by an invaluable description in Francesco Agostino Della Chiesa's well-known treatise *Fiori di Blasoneria per Ornar la Corona di Savoja con i freggi della Nobiltà* (fig. 9), published in Turin in 1655 and republished in the same city in 1777: "Bassi di Sauona: due ponte azurre contraposte, in campo d'oro; ouero come dicono altri, trinchiato, e tagliato, azurro & oro," where the words "trinchiato e tagliato," meaning "party per saltire," or "diagonally both ways," is used to point out an alternative way of indicating the St. Andrew's Cross.[20]

Antonio Manno, one of the greatest heraldry scholars of all time, granted this distinction in his monumental *Patriziato subalpino* (1895–1896) and, in reference to the "Basso. Da Savona. Conti di Bistagno", specified in a note: "Nei *Fiori di blasoneria* è detto: d'oro a due punte d'azzurro contrapposte. In questo caso, fra le due punte, dovrebbe esservi una breve distanza".[21] The Basso Della Rovere "opposing points" can be seen today in the family coats-of-arms in the church of Santa Maria del Popolo in Rome, in both the family chapel on the right aisle, which we will return to below, and on the base of the renowned funerary monument of Cardinal Girolamo Basso Della Rovere, sculpted by Andrea Sansovino and located in the choir (fig. 10), as well as in the basilica of the Casa Santa di Loreto, of which Girolamo was long protector and an active patron (fig. 11).[22]

Following his marriage to Caterina, Antonio could now adopt the renowned insignias of the royal house of the Neapolitan Aragonese granted to him by the king of Naples, Ferdinand I, one of the Renaissance coat-of-arms with a more complex gestation. It is a quartered shield that unites the original arms of the royal house of the Trastámara of Aragon (distinguished by a gold field with four pallets of gules) and the tierced palewise coat-of-arms of the Angevin crown of Naples that was adopted in the fourteenth century by the Durazzo Angevins and features the arms of Hungary, the Anjou, and Jerusalem (fig. 12).[23] The heraldic configuration of the Anjou and Aragon arms in the same shield explicitly evoked the dynastic continuity between the two families, recognizing the latter's legitimate inheritance of the crown of the kingdom of Naples, which was also linked to dynastic claims over the kingdoms of Hungary and Jerusalem, already advanced by the Angevins and reasserted by the Aragonese.[24] This coat-of-arms was adopted by Alfonso I and his son Ferdinand I and offered generously as arms of matrimonial alliance and concession of feudal titles as well as, in very special cases, as an honor for those who had distinguished themselves through merits accumulated with the Crown. The position of the Angevin and Aragonese quarters in the royal coats-of-arms of the two sovereigns does not, however, appear to have been stable.[25]

Imagining the coat-of-arms on the heraldic right of the Acton overdoor with the metals and tinctures of the Basso, Della Rovere, and Aragon families, the blazon or description of the shield would be the following (fig. 13): per pale, 1st Azure, an oak tree eradicated Or bearing fruit with doubly decussate branches on two opposing points on the lowered fess Or (arms

Fig. 11 Benedetto da Maiano, *lavamano* of the sacristy of San
Giovanni, marble, 1481, Basilica della Casa Santa, Loreto.

of Basso Della Rovere); 2nd quarterly, 1st and 4th Or, paly of four Gules (arms of Aragon), 2nd and 3rd tierced per pale (arms of Anjou-Durazzo), 1st Argent barry of five Gules (arms of Hungary), 2nd Azur, semé-de-lys Or (arms of Anjou), 3rd Argent, a cross potent between four plain crosslets Or (arms of Jerusalem).[26]

As we have already noted, the side shields of the Acton overdoor are perfectly facing one another, and what this corresponds to is a common heraldic convention of facing the arms "out of courtesy," but in this particular case it was taken far beyond the aim of creating simple compositional symmetry. In this arrangement, we can see in both shields that the Basso Della Rovere arms always occupies the two outside partitions, while that of the Royal House of

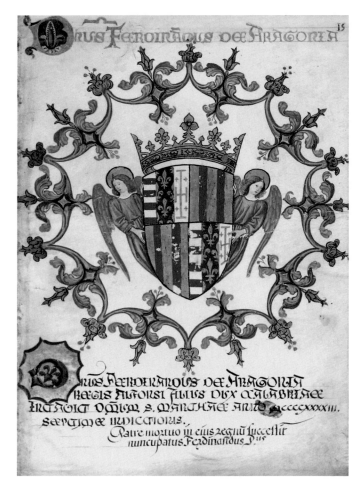

Fig. 12 Coat-of-arms of Ferdinand I Trastamara of Naples and
Aragon, mid-15th century, in *Codice di Santa Marta*, fol. 15,
Museo dell'Archivio di Stato di Napoli.

Aragon occupies the inside partitions. This changes the direction for reading the partitions
of the shield and thus the arms' order of precedence, inverting the relationship of power and
alliance established between the two families. If this reading is correct, the shield on the
heraldic right expresses the fact that the Basso Della Rovere brought the arms of the royal
house into their own shield, literally creating space for Caterina when she entered the new
family (fig. 5). It is the exact opposite in the shield on the heraldic left. The Aragonese arms of
concession, and with it Antonio's ducal rank, are presented in the first partition in accordance
with custom, while those of the Basso Della Rovere are presented in the second partition on
the heraldic left in an act of submission (fig. 6).

"Familia De Ruvere olim Basso"

T he Basso was an old family originally from Savona and Albisola that, starting in the fourteenth century, was granted a seat in the Community of Elders, the *Anzianìa*, the highest chamber of the city's government. The notary Giovanni di Guglielmo Basso[27] became involved in the political life of Savona in the second quarter of the fifteenth century, when the city was enjoying the apex of its maritime and commercial power under the Milanese government of the Sforza.[28] From 1429 to 1431, he is documented as having undertaken a mission as ambassador to Milan and Genoa, sent by the *Anzianìa* to negotiate with the representative of the Sforza duke several conditions that would benefit the city.[29] Still unknown are the dates at which Giovanni became a knight, and that of his wedding to Luchina della Rovere, the favorite sister of the future Sixtus IV, a marriage that granted him the new name of Basso Della Rovere.[30] Giovanni's firmly established social status is confirmed by October 18, 1481, when he is documented as having purchased the fief of Bistagno and Monastero Bormida from the Spinola family for 12,000 scudi.[31]

Giovanni and Luchina had six sons and one daughter: the aforementioned Girolamo, elected cardinal in 1477;[32] Antonio, Caterina Marzano d'Aragona's husband; Francesco, knight of the Order of Saint John of Jerusalem and prior of Pisa and Lombardy;[33] Guglielmo, married to Maria di Urbano Intelminelli;[34] Bernardino, about whom very little is known and who probably predeceased the others; Bartolomeo, who married Battistina Testadoro and ended up inheriting everything, founding a prolific and celebrated line of descent;[35] and Maria, married to Antonio Grosso, who following that marriage became Grosso Della Rovere, and whose descendants included, among others, the cardinals Clemente and Leonardo, the bishops Galeazzo Antonio and Francesco Andrea, and others including the rich and powerful Bartolomeo.[36]

Antonio was born in Savona, where he continued to handle the family affairs, until the 1470s. Through the pope's favor, he obtained "in emphyteusis" the seigniory of the castles of Cisterna d'Asti and Belriguardo between 1473 and 1477.[37] Together with his father Giovanni, Antonio was one of the first Savonese to invest his own funds in the acquisition of fiefs and seigniories in the Savona hinterland. His prestige within the Della Rovere clique must have grown quickly, since he was chosen on December 9, 1478, as the spokesperson to officially communicate to the Elders of Savona the elevation of his brother Girolamo the previous year to the rank of cardinal. From this point forward, Antonio was able to benefit considerably from his brother's position in the Roman curia, eventually moving to Rome, where he quickly received numerous posts and privileges, including the title of count palatine of the Lateran, the offices of rector of the province of Campagna and Marittima (1476), and possibly the governorship of Terracina.[38]

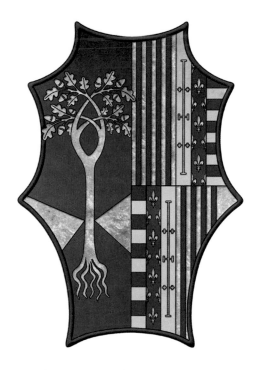

Fig. 13 Reconstruction of the metals and tinctures of the
coat-of-arms of Antonio Basso Della Rovere d'Aragona.

"Antonio Basso Ruvere de Aragonio"

M ost of what we know about the last part of Antonio's life derives from the celebrated *Diario romano* by Jacopo Gherardi, called "il Volterrano", a remarkable chronicler and valuable source for the events that took place during that period. Secretary to Cardinal Jacopo Ammannati Piccolomini from 1463, upon the latter's death in September 1479, Gherardi passed into the service of Antonio Basso Della Rovere, who quickly recommended him to the pope, winning him the post of "cameriere d'onore."[39] Written in a grateful and emotional tone, the *Diario romano* records Antonio's brief period in Rome, from his sumptuous wedding to Caterina in November 1479 to his early death in August 1480.[40]

Caterina was born to the powerful Marino Marzano and Eleonora d'Aragona, a natural daughter of King Alfonso I and stepsister of his successor Ferdinand I. A figure of central importance in the politics of the house of Aragon, Marino had been high admiral of the kingdom of Naples, prince of Rossano, duke of Sessa, and count of Squillace. Long a faithful follower of Alfonso I, when the king died in 1458, Marino found himself in increasing conflict with the government of the sovereign's natural son and heir Ferdinand I, quickly ending

up supporting the baronial revolt and aiding the return of René of Anjou to the Neapolitan throne. Between rebellions, pacts, and betrayals, Ferdinand had no peace until he managed to arrest Marino and his son Giovanni Battista in 1464, condemning them to a long, hard imprisonment, during which Marino died, possibly in 1489.[41] On the contrary, Eleonora and their four daughters, including Caterina, were supported financially by the king, first in Anversa and later in Capua, living in such splendor that chroniclers of the time wondered whether she was in an incestuous relationship with her half-brother the king.[42]

We know from Gherardi that, for her wedding to Antonio, Caterina arrived in Rome the evening of Saturday, November 18, 1479, accompanied by Lazzaro Feo, Savonese ambassador at the papal court. She stayed the night as the guest of her cousin Giovanni della Rovere d'Aragona, in the prefect's residence adjacent to the church of San Pietro in Vincoli. On the next day, a Sunday, she was led to the Vatican on a white horse given to her by the pope. The nuptials were celebrated in St. Peter's Basilica "cum maxima pompa" by Guglielmo Rocca, archbishop of Salerno, and ended with the homage of the newlyweds at the feet of the pope.[43] The "more regio" banquet was held in the small palace on via Tordinona "ad Tyberis ripam" where the cardinal Girolamo Basso Della Rovere had lived, and where the cardinal Alessandro Oliva and the above-mentioned cardinal Ammannati had also resided, the latter having transformed it into one of the most lively humanist centers in recent Roman memory.[44]

Antonio lived in the palace for just a few months, dying of an illness on August 12, 1480. Il Volterrano movingly describes the dying man's twelve days of agony, the devotion with which his wife Caterina attended him, "virgo regia, spetie et pietate pręclara", and the arrival of siblings, relatives, physicians, and men of the cloth at his deathbed.[45] The chronicler then describes the visit of Sixtus IV and that of Antonio's powerful cousin, the count Girolamo Riario, the most hateful and hated among the pope's relatives. Gherardi further reports an episode that allows us to better understand the complex dynamics and conflicts that developed over the years within the Della Rovere family. During Count Girolamo's visit, Antonio, acutely aware of having led his own life, now at its end, beyond reproach, found it impossible to contain himself and burst out against his cousin's corruption and abominable moral conduct. The spontaneous accusation was awkward, unleashed as it was in public before all present.[46] Antonio was buried in the tomb prepared eight years earlier upon the death of his mother Luchina, reworked for his own death by the sculptor Lorenzo da Pietrasanta in September 1480, in the same Sistine Chapel in St. Peter's Basilica where the bronze monument of the pope was later installed.[47] Lacking an heir, Caterina was able to retrieve her dowry, as noted above, and she returned to Naples on May 30, 1481, accompanied by Oliviero Caracciolo, "montiere maggiore" of Ferdinand I.[48] The *Diario romano* adds little else about Antonio, noting his mild, simple habits and the fundamental support he provided to his brother-in-

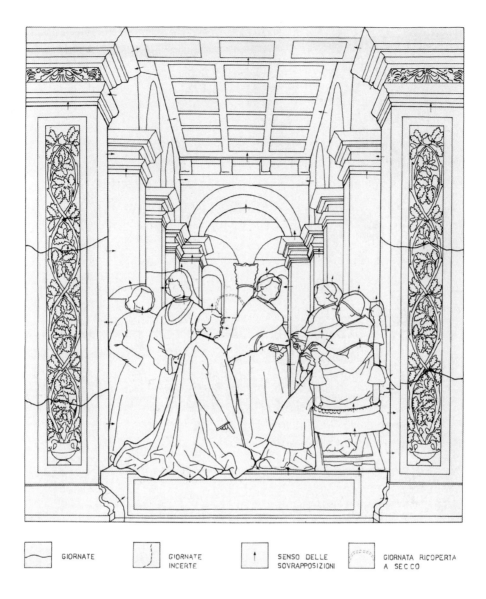

| | GIORNATE | | GIORNATE INCERTE | ↑ | SENSO DELLE SOVRAPPOSIZIONI | | GIORNATA RICOPERTA A SECCO |

Fig. 14 *Giornate* of the fresco *Pope Sixtus IV Appoints Platina Prefect of the Vatican Library* by Melozzo da Forlì, in Carlo Giantomassi, Donatella Zari, *Relazione tecnica sull'intervento di restauro* [object file, 1987], Pinacoteca Vaticana, Musei Vaticani (published in Ruysschaert 1989, p. 42).

law Leonardo Tocco di Leucade (husband of his wife's sister, Francesca Marzano d'Aragona), despot of Arta in the Epirius region of Greece, after being driven from his realm during the Ottoman invasion of 1479.[49]

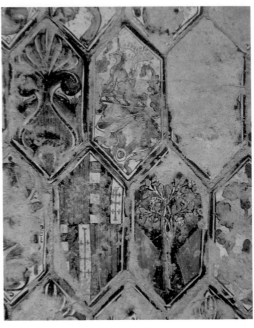

Fig. 15 Basso Della Rovere chapel, Santa Maria del Popolo, Rome.

Fig. 16 Floor tiles, ceramic, c. 1480, Basso Della Rovere chapel, Santa Maria del Popolo, Rome.

It is possible that the clash between Girolamo Riario and Antonio Basso Della Rovere contributed to obscuring the memory of the latter. This theory was put forward multiple times by Father José Ruysschaert, according to whom Antonio was included in the first version, prior to 1477, of the famous fresco by Melozzo da Forlì of Sixtus IV surrounded by his nephews while appointing Bartolomeo Platina prefect of the Vatican Library. The name "Antonio" cited in the *De omnium scientiarum in laudem Sixti Quarti Pontificis Maximi*, written by Antonio de' Tomeis between 1477 and 1478 and containing a substantial passage in praise of Melozzo's painting, would seem to refer to Antonio Basso Della Rovere.[50] Indeed, the most recent restoration of the work has confirmed that a figure painted earlier by Melozzo between the head of Platina and the left window, behind Cardinal Giuliano, who is standing in the middle of the painting, was covered up *a secco*. According to Ruysschaert this was a *damnatio memoriae* of Antonio orchestrated by Girolamo Riario, using his influence over the pope to punish his relative's impudence *postmortem* (fig. 14). Gherardi reports that Guglielmo, Antonio's brother, continued to live in the small palace on the Tiber until he died there of the plague on July 13, 1482, whereas their father Giovanni lived in his own home near the Vatican Basilica, where he was visited in his eighties and on the brink of death by his brother-in-law the pope on August 3, 1483.[51] Giovanni died on August 31, 1483 and was buried in the church of Santa Maria del Popolo in Rome, in the third chapel on the right.

Dedicated to St. Augustine, the Basso Della Rovere chapel received an endowment of 200 ducats from Cardinal Girolamo on April 22, 1484 (fig. 15).[52]

The chapel's extraordinary floor, made up of 1,650 hexagonal majolica tiles arranged in a beehive pattern, seems to have been the first work commissioned for the space. In spite of substantial losses, it is a quite complex cycle with a wide range of themes: floral scrolls, oak branches, star motifs, peacock feathers, and, in particular, heraldic devices similar to the ones in the side coats-of-arms of the Acton overdoor, specifically, the uprooted oak between gold points of the Basso family, the Neapolitan and Aragonese quartered shield, and the crest with a unicorn in the shade of an oak tree (fig. 16).[53] Taking into consideration the various theories for the dating of the floor and the provenance of the ceramicists, it seems reasonable to surmise that the tiles were made in Rome by itinerant artists well-versed in contemporary production in Pesaro, Deruta, and Naples in the 1480s, around the time of the first endowment by Cardinal Girolamo, long before the pictorial and sculptural decoration of the chapel were began. The close resemblance between the heraldic themes of this magnificent floor and Antonio's personal device leads us to imagine, cautiously, that this work might have actually been commissioned a few years earlier than supposed, coinciding with the dating of the Acton overdoor and the date of Antonio's wedding.[54]

Girolamo was unquestionably the patron of the marble monument dedicated to his father, the epitaph of which mentions the three surviving sons: Girolamo, Francesco, and Bartolomeo:

<div style="text-align:center">

IOANNI DE RVVERE . XYSTI . IIII . PONT . MAX . SORORIO

CIVI SAONEN . ORDINIS EQVESTRIS . QVI VIX.

ANN . LXXX . M . VII . D . X . HIER CARDINALIS

RECAN . FRANCISCVS PRIOR PISANVS . BARTHOLAMEVS

FILII SVPERSTITES PATRI BNMEREN POSVER

OBIIT . M . CCCC . LXXXIII DIE XVII AVGVSTI.[55]

</div>

According to Francesco Caglioti, this monument, like the framing structure for the altar and the lost antependium, was the work of Matteo Pellizzone from Milan, who carved them between 1501 and 1502 (fig. 17, fig. 18).[56] This date is significantly later than those previously proposed and closer to the dating of the chapel's fresco cycle, which is pinpointed in the most reliable studies to the very first years of the sixteenth century, and seems to be the work of Pinturicchio with probable assistance from the Sienese Giacomo Pacchiarotto and Girolamo del Pacchia.[57] Given the current state of our documentary knowledge, it would seem that little more can be added about Antonio Basso Della Rovere's Roman period. Rome, in any case, is certainly not where the original location of the Acton overdoor is to be found.

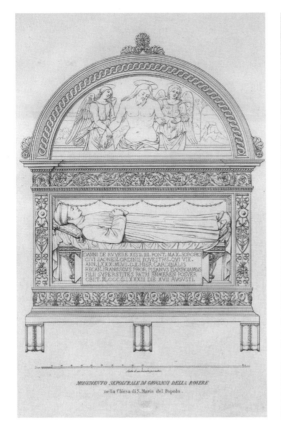

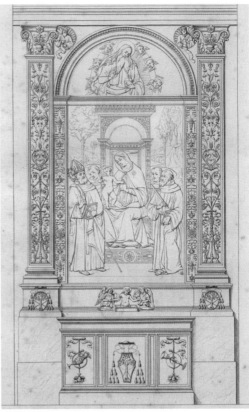

Fig. 17 Monument of Giovanni Basso Della Rovere, Basso Della Rovere chapel, Santa Maria del Popolo, Rome, illustration from Francesco Maria Tosi, *Raccolta di monumenti sacri e sepolcrali scolpiti in Roma nei secoli XV e XVI, misurati e disegnati dallo architetto cav.r Francesco M.a Tosi ed a contorno intagliati in rame da valenti artisti* [...], V, [Rome], 1856, plate CXXIV.

Fig. 18 Altar of the Basso Della Rovere chapel, Santa Maria del Popolo, Rome, illustration from Francesco Maria Tosi, *Raccolta di monumenti sacri e sepolcrali scolpiti in Roma nei secoli XV e XVI, misurati e disegnati dallo architetto cav.r Francesco M.a Tosi ed a contorno intagliati in rame da valenti artisti* [...], V, [Rome], 1856, plate CXXVII.

"La casagrande del detto Antonio Della Rovere"

Although highly unique, the Acton overdoor fully fits within the Ligurian overdoor tradition and expresses the figurative and stylistic conventions of a work created for an urban context. The commission of such a modern, innovative monumental sculpture would be unjustified for any of Antonio's fiefs in the Ligurian hinterland, its heraldic message expressly addressed to an audience increasingly engaged in and aware of the social, economic, and political transformations underway in the Della Rovere sphere, directly depending on the pope's favors, which leads us to consider Savona as the most natural location for the overdoor.[58] No doubt can remain over the dating of the commission of the work to around 1479, the year

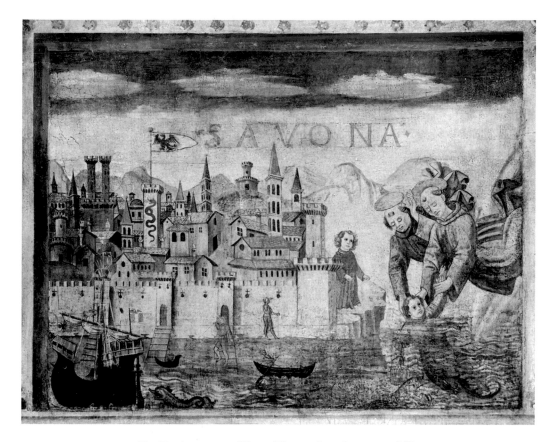

Fig. 19 Anonymous, View of Savona from the scene of *The Young Francesco Della Rovere miraculously saved from drowning in the waters of Savona thanks to the miraculous intervention of Saint Francis and Saint Anthony*, fresco, c. 1476-1480, Corsia Sistina, Ospedale di Santo Spirito in Sassia, Rome, (published in Howe 2005, p. 228, fig. 27).

of Antonio's wedding, a date perfectly compatible with the style of the relief. Right on cue, the Acton overdoor demonstrates Antonio Basso Della Rovere's capacity to exploit the new Renaissance language for the expression of his improved social status.

The economic and social growth of Savona under the role of Galeazzo Maria Sforza, between 1464 and 1476, was marked by the renovation of buildings on Priamàr Hill around the old cathedral, and the construction of a new shipyard, the *darsena*, between 1472 and 1473.[59] These important projects significantly increased port activity, and consequentially led to the development of trade relationships with other centers. But it was only starting in 1480, when Savona began to gradually pass under Genoese control, that the new mercantile prosperity sparked off what is commonly called the Della Rovere age, opening up the city to

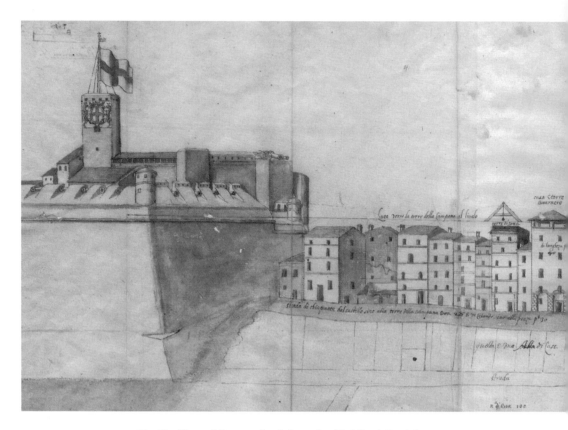

Fig. 20 View of Savona, detail from the *Modello della città e fortezza di Savona fatta intorno alla torre della campana del Comune*, pen and ink drawing, after 1583 before 1611, Archivio di Stato di Genova.

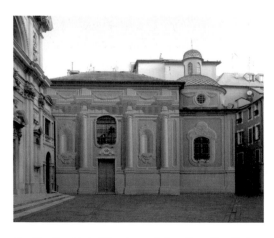

Fig. 21 Exterior side view of the Cappella Sistina, Savona.

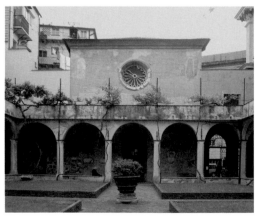

Fig. 22 Cloister of the former friary of San Francesco with the facade of the Cappella Sistina, Savona.

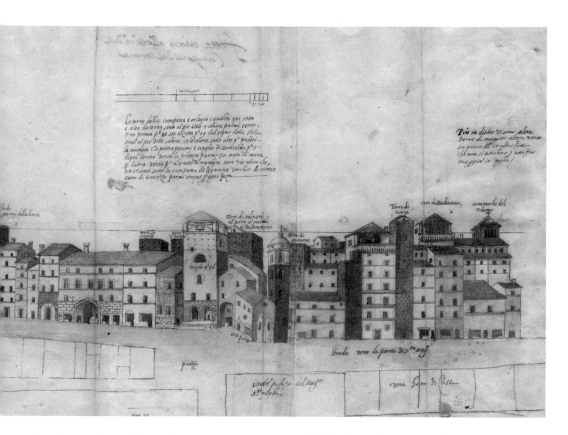

the innovations of Renaissance art (fig. 19, fig. 20).[60] The first glittering milestone of this new artistic direction was undoubtedly the opening of the worksite for the Cappella Sistina in 1481 (fig. 21, fig. 22), built as a chapter house for the friary of San Francesco and destined by Sixtus IV to house the tomb monument of his parents, Leonardo Della Rovere and Luchina Monleone, originally located in the apse-like area of the same space (fig. 23).[61] The chapel and monument were part of a single project that was undoubtedly formulated in Rome in the preceding years, the architectural aspects possibly having been developed in the workshop of Baccio Pontelli and the design of the marble tomb in all probability in that of Andrea Bregno. We learn from one document that the design for the monument was sent to Savona in October 1481 with two papal delegates who entrusted the work to the brothers Michele and Giovanni d'Aria, with blocks of marble sent specially from Carrara.[62] This work site was the first of three that, decade by decade, marked the most important phases of Della Rovere artistic magnificence.[63] The second opened in 1495 was the vast palace of Cardinal Giuliano della Rovere on via dei Nattoni, built on designs by Giuliano da Sangallo from 1493 with the work overseen by Matteo da Bissone (fig. 24, fig. 25).[64] The third, commissioned by Giuliano and opened on the Priamàr Hill in 1500, was the reconstruction of the bishop's palace and the creation of a magnificent wooden choir with splendid intarsia stalls for the adjacent cathedral of Santa Maria di Castello (fig. 26).[65]

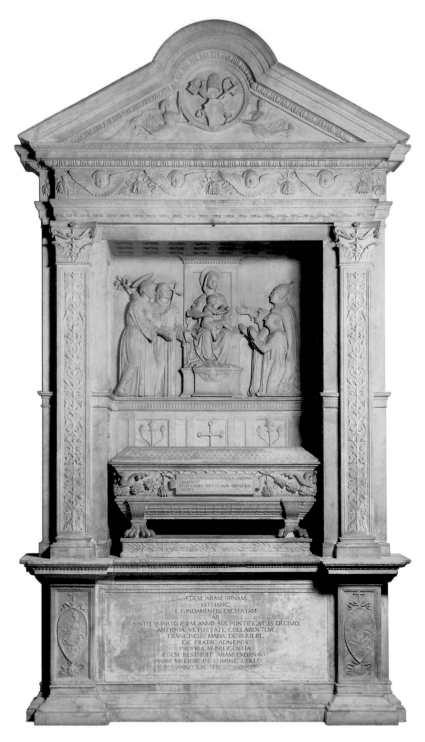

Fig. 23 Monument of Leonardo Della Rovere and Luchina
Monleone, parents of Sixtus IV, marble, 1481-1482, Cappella
Sistina, Savona.

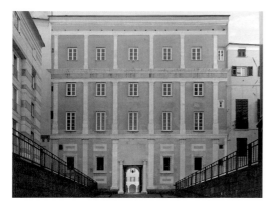

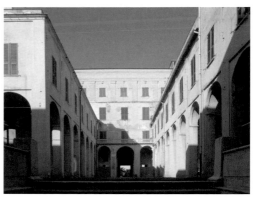

Fig. 24 Facade of the palace of Giuliano Della Rovere, plan begun by Giuliano da Sangallo in 1493, Savona.

Fig. 25 Courtyard of the palace of Giuliano Della Rovere, plan begun by Giuliano da Sangallo in 1493, Savona.

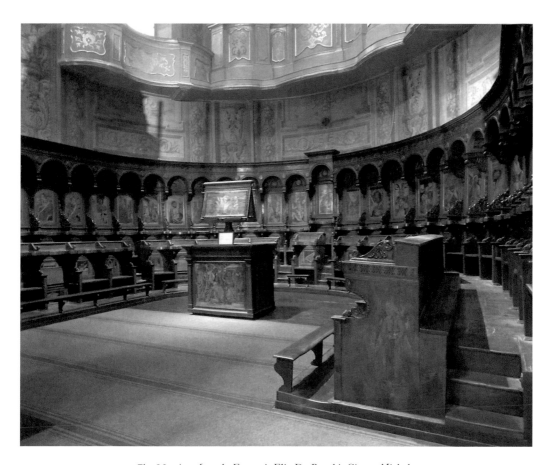

Fig. 26 Anselmo de Fornari, Elia De Rocchi, Giovan Michele Pantaleoni, choir with wooden stalls from the old cathedral, 1500-1522, cathedral of Santa Maria Assunta, Savona.

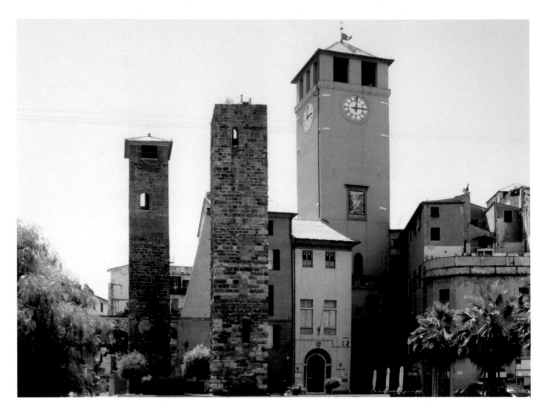

Fig. 27 Piazza del Brandale, Savona.

Fig. 28 Savona at the end of the 15th century.

And yet the profound change to the urban face of Savona had already begun with the slow but progressive transformation of individual buildings by a ruling mercantile class that, in spite of the old factions that opposed the noble Guelphs and the popular Ghibellines, was enjoying an economic recovery of sorts and found itself strongly united in the establishment of new trade alliances and ready to overhaul the appearance of their city residences.[66] A few important architectural changes were made in the area of Piazza del Brandale, the political and administrative center of the city, as home to the Palazzo del Podestà, which also functioned as a law court, the Palazzo dell'*Anziania*, adjacent to the Loggia dei Popolari, and the residences of the Sansoni and the Riario, who were soon interrelated with the Della Rovere (fig. 27, fig. 28).[67] But the greatest transformations were made in the area of Piazza della Maddalena, seat of the wealthy mercantile patriciate and the Loggia dei Nobili, to which the Spinola belonged, and where the Della Rovere family lived, not far from the Vegerio, Basso, and Grosso, who were soon all members of the large Della Rovere faction (fig. 29). Amidst this new commercial and demographic prosperity, the area between Piazza Brandale and Piazza Maddalena saw its

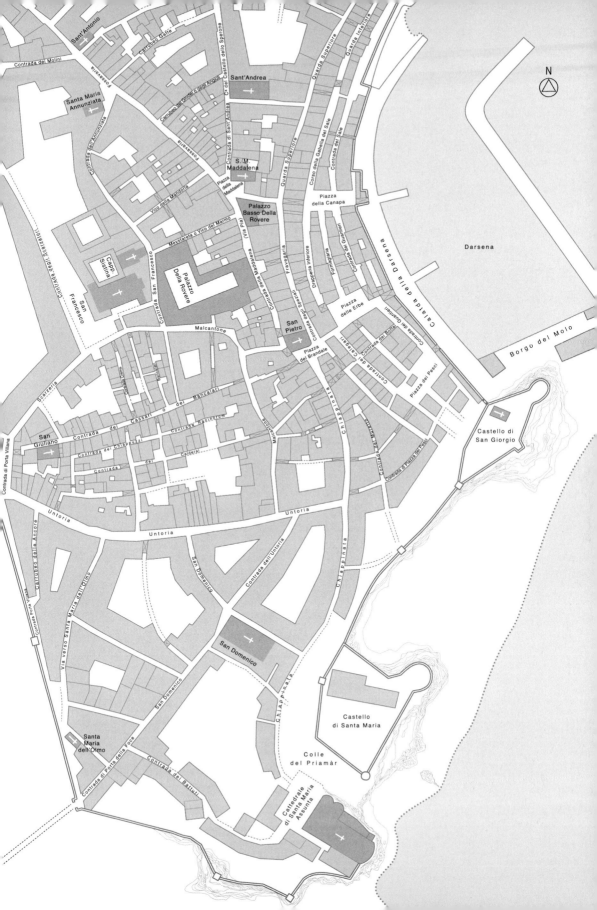

N

Sant'Antonio

Contrada del Molini

Carrubeo Gatte

Fossavaria

Contrada dello Sperone

Cr del Castello dello Sperone

Sant'Andrea

Santa Maria
Annunziata

Contrada dell'Annunziata

Fossavaria

Carrubeo del Quinto o Vigo Angeli

Contrada di Sant'Andrea

S. M.
Maddalena

Quarda Superiore

Quarda Superiore

Quarda Interiore

Corso della Gabella del Sale

Contrada del Sale

Piazza
della
Maddalena

Vico della Mandoria

Mandolecla c Vico del Marmo

Palazzo
Basso Della
Rovere

Piazza
della Canapa

Darsena

Capp.
Sistina

Contrada degli Scarzaloti

Contrada San Francesco

Palazzo
Della Rovere

(Via Pila)

Contrada della Maddalena

Fregavaria

Frezzada

Drapperia Inferiore

Formaquaria

Contrada dei Guanteri

San
Francesco

Piazza
delle Erbe

Contrada dei Guanteri

Calaida della Darsena

Malcantone

San
Pietro

Contrada degli Argenti

Piazza
del Brandale

Contrada dei Calegari

Borgo del Molo

Contrada del Botto

Piazza dei Pesci

Scarzeria

Contrada dei Cassari o dei Bancalari

Contrada del Banco

Contrada del Botto

Contrada dei Battiloro

San
Giuliano

Contrada dei

Contrada Reguleorum

Calaida

Calderai

Maina

Chiappa

Castello di
San Giorgio

Contrada di Porta Villana

Contrada dei Chiapazzi

del

Contrada

Maina

Contrada di Piazza del Pesci

Untoria

Untoria

Untoria

Contrada dell'Untoria

Chiappinata

Carrubeo della Ancore

San Domenico

San Domenico

Via verso Santa Maria dell'Olmo

Contrada Porta Villana

San Domenico

San Domenico

Chiappinata

Castello
di Santa Maria

Santa
Maria
dell'Olmo

Contrada di Porta della Foce

Contrada dei Battuti

Colle
del Priamàr

Cattedrale
di Santa Maria
Assunta

Fig. 29 Piazza della Maddalena, Savona.

towers knocked down, loggias filled in, facades frescoed, covered roof terraces built, and, on the model of examples in Genoa, construction of the monumental portals with sculpted overdoors that remain one of the most interesting contributions to the Savona Renaissance.[68]

The original Palazzo Basso Della Rovere in Savona still stands on the corner between Piazza della Maddalena and via Pia, the old contrada della Maddalena, also called via dei Nattoni (fig. 30). The importance of this building emerges early on in a contract drawn up by the notary Tommaso da Moneglia on January 23, 1481, in relation to the sale of a notions shop located beneath what came to be known as the "casagrande" (big house) of "Antonio Della Rovere olim Basso", who had died the year before.[69] The sole heir of the Savona assets of the Basso Della Rovere family was, as we have seen, "il magnifico" Bartolomeo Basso Della Rovere, still listed as one of the richest men in Savona in the *Libro de la Caratata*, a unique tax register from 1530, even though he had already died by that date.[70] A source of fundamental importance for the economic and social history of the city, the *Libro de la Caratata* contains invaluable information about Genoa's taxation of Savona properties during the period when Genoa was beginning its systematic mortification of city liberties.

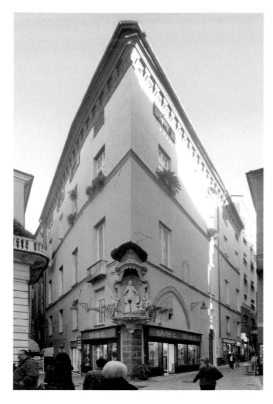

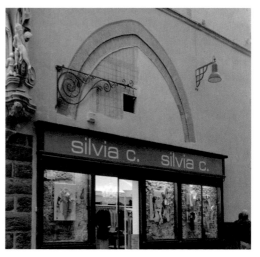

In the important study prepared by Carlo Varaldo on this fiscal document, Palazzo Basso Della Rovere alla Maddalena was found to be seventh among the largest and most heavily taxed palaces in the city, in the sum of 2,000 lire, the same as the palaces of Lorenzo Gavotti and Battista Del Carretto (2,000 lire), and preceded on the list by those of Stefano Vegerio (2,200 lire), Conreno Chiabrera (2,500 lire), Francesco Spinola (3,000 lire), Andrea Gentil Ricci (4,000 lire), Carlo Del Carretto (previously belonging to the Pavese and then to the archbishop of Avignon, Rolando Del Carretto; 4,500 lire) and, finally, Bartolomeo Grosso Della Rovere, with the vast palace designed by Sangallo (built by Cardinal Giuliano, acquired from his heir Francesco Maria, duke of Urbino, in 1513; 10,000 lire).[71]

According to seventeenth-century chronicler Giovanni Vincenzo Verzellino in *Memorie particolari e specialmente degli uomini illustri della città di Savona*, the Basso Della Rovere lived in their home in Piazza della Maddalena for the entire sixteenth century, although by Verzellino's day it was already in the possession of the nobleman Francesco Multedo.[72] The palace is a heavily altered medieval building with two stories and mezzanines above the ground floor and in the attic. The building's facades are plastered and marked with simple

Fig. 33 Portal on via Pia 15, Palazzo Basso Della Rovere, Savona.

medieval stringcourses, an original fragment of which survives, made of alternating blocks of slate and white marble carved with vegetal motifs, on the lower corner of the southernmost section along via Pia (fig. 31). The building is crowned by a cornice that was added much later, with coupled consoles alternating with square panels of various subject. It is highly probable that the medieval ogival loggia on the corner overlooking the piazza was closed up during the 1470s (fig. 32), and thus during Antonio's time, but it could also have been done subsequently, in the first two decades of the sixteenth century, under Bartolomeo, to which the transformation of the entrance atrium and the stairwell may be dated on stylistic grounds.[73] The main portal to the palace, at via Pia 15 (fig. 33), stands opposite the narrow vicolo di Meystareta, now vico del Marmo, which leads directly to the apse of the *Cappella Sistina*, skirting the palace designed by Sangallo for Giuliano della Rovere on the left.[74] Since this entrance has always remained the same, as it provides the sole access to the upper floors of the palace, we now need to explain the relationship between this portal and the Acton overdoor in Florence.

"Marble doorframe found in Savona:" a Boston interlude

The structure of the portal on via Pia comprises two jambs topped by a round arch, decorated with a sculpted motif of grape vine shoots with vine leaves and bunches of grapes, all emerging out of large, two-handled bowls. The motif of plant-like spirals coming out of vases is characteristic of a noteworthy family of highly refined sculpted works made during the early Ligurian Renaissance.[75] Among these can be identified a specific tendril type found on the jambs of our Savona portal, the oldest example of which seems to be identifiable in the marble *Crucifixion* commissioned in 1443 by Girolamo Calvi for his chapel in the cathedral of San Lorenzo in Genoa (fig. 34). The same artist may also have sculpted the marble tabernacle formerly in the church of Santa Maria della Pace in Genoa, now in the Museo di Sant'Agostino, the base of which is decorated with the same flat, broad vine leaf motif (fig. 36).[76] This same motif is also found in Genoa in the black stone frame of the Grimaldi tomb slab depicting a *Morte Secca*, or desiccated skeleton, now inserted into a wall on the second level of the cloister of the Church of Santa Maria di Castello (fig. 35), and in two other monumental portals with *St. George and the Dragon*: one at the Bode-Museum, Berlin, of unknown provenance and generically dateable to 1460 (fig. 37);[77] the other, later and quite elegant, still *in situ* at the entrance to Palazzo Spinola in Piazza di Pellicceria 3 (fig. 38).[78]

The via Pia portal was not the only one in Savona with similarly carved jambs. One example, cited by Luigi Augusto Cervetto in his monograph *I Gaggini da Bissone* (published 1903), is unfortunately now lost:

Fig. 34 *Crucifixion*, formerly in the chapel of Girolamo Calvi, marble, 1443, cathedral of San Lorenzo, Genoa.

Fig. 35 *Morte Secca*, tomb slab of the Grimaldi family, marble and black stone from Promontorio, 1445-1453, Santa Maria di Castello, Genoa.

Savona – Via Quarda Superiore – Portale in marmo di Carrara con la storia di S. Giorgio fiancheggiato da due targhe con stemmi. Nel campo sono le iniziali D. M. Tutto attorno agli stipiti corre in intreccio di tralci, foglie e grappoli di vite come in parecchi portali di Genova, specie in quello esistente sulla Piazza Pellicceria. Lo stile è di Giovanni Gaggini.[79]

We can add to this example a portal that has until now almost completely escaped the attention of scholars, noted solely in a passing by Walter-Hanno Kruft.[80] This is the portal once installed as the main entrance to the Isabella Stewart Gardner Museum, Boston, facing the Fenway (fig. 39).[81] It features an overdoor representing *St. George and the Dragon* in a style that is difficult to identify and a frame carved with tendrils identical to those on the via Pia portal (fig. 40). Its provenance from Savona was completely unknown until now, discovered following my request to consult the museum's object files.[82] One of these documents is dated

Fig. 36 Eucharistic altar, formerly in Santa Maria della Pace,
painted marble, c. 1445, Museo di Sant'Agostino, Genoa.

October 6, 1897, and lists works of art purchased in Italy by Isabella Stewart Gardner, already
crated in Florence and ready to ship. Written in Italian, the document is validated with an
official stamp and signed by Emilio Costantini, artist and professor of painting at the Scuola
professionale di Arti Decorative e Industriali (later known as Istituto Statale d'Arte), who
added that he had already received payment for the service.[83] Introduced to Isabella Stewart
Gardner by Bernard Berenson some time earlier, Costantini is known in the literature
as an important art dealer active in those years in the Florentine antiquarian market. The
list of works includes the portal and its provenance: "1 Porta di marmo scolpita, con fregio
contenente l'allegoria di S. Giorgio. Proveniente da Savona presso Genova e fatta all'epoca dei
Doria (1400). Lit. 8000,00".[84] A later note added in pencil records its entry into the collection
and installation as the palazzo's main entrance. The same lines are translated in English on
another sheet.[85] A final receipt summarizes the calculation of expenses for the purchase of the

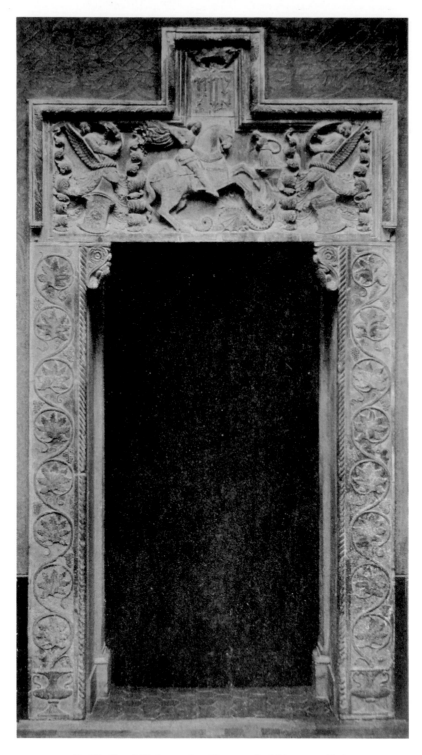

Fig. 37 Portal, black stone from Promontorio, 15th century, Bode-
Museum, Berlin (published in Schottmüller 1922, plate 44a).

Fig. 38 Portal, Palazzo Spinola, marble, late 15th century,
Piazza di Pellicceria 3, Genoa.

Fig. 39 Portal on the Fenway, Isabella Stewart Gardner Museum,
Boston (modern copy).

Fig. 40 Overdoor with *St. George and the Dragon*, marble,
c. 1470, Isabella Stewart Gardner Museum, Boston (original).

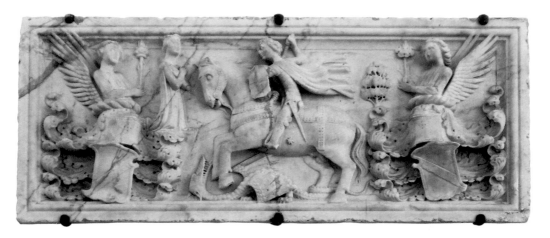

Fig. 41 Overdoor with *St. George and the Dragon*, marble,
c. 1470, Palazzo Gavotti, Savona.

work and the applied discount (fig. 42): "Florence 1897. Prof. Emilio Constantini. Oct. 6. I.G. lire 40.700 (paid for by her cheque on B.S. & Co. for £ 1.541.13.4)."[86]

Further authoritative, however brief, confirmation of the Savona provenance of the Boston portal, this time on the basis of style, is also preserved in the object files. The document, a handwritten report by John Pope Hennessy dated August 17, 1971, was requested of the scholar by the museum curators in preparation for a larger project to publish a catalogue of the museum's sculptures. Pope Hennessy's comments reveal an interesting exchange of opinions between himself and Kruft:

> Doorway with St. George and the Dragon. I have shown this photograph to Kruft, who confirms my own belief that the door comes from Savona. There is a related door on the staircase of the Museo Communicale (*sic*) there. The vine leaf ornament appears on another door in Savona.[87]

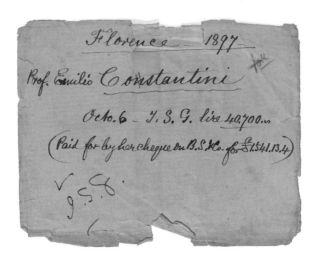

Fig. 42 Invoice dated October 6, 1897, Object files Archive,
Isabella Stewart Gardner Museum, Boston.

The first door is clearly identifiable at the overdoor of uncertain provenance portraying *St. George and the Dragon*, now walled into the main stair of Palazzo Gavotti in Savona (fig. 41), a considerably more complex and refined work than the one in Boston. The second door refered to here can only be the main entrance to the Basso Della Rovere palace in via Pia.[88] Kruft was indeed the first scholar to have noticed the portal at via Pia 15, and to observe a connection between the vegetal motifs in both contained in the pilasters of both. In his short volume *I portali genovesi del Rinascimento* (1971), we find this brief comment in a note:

Il portale a Savona, via Pia, 15, reca in basso a destra l'iscrizione probabilmente aggiunta più tardi: L.M. 1690. A cosa si riferisca la data non sono in grado di spiegarlo. Ad ogni modo il portale è un lavoro del Quattrocento.[89]

No objections were made to this dating, with the exception of a brief comment made by Manuela Villani in a note in a 2006 essay on Lombard sculptors working in Savona at the end of the fifteenth century:

L'accentuato calligrafismo del decoro nel portale di via Pia e la forma centinata rendono un po' sospetta l'autenticità del manufatto, almeno nella sua integrità. La data «1690» incisa alla base dello stipite destro potrebbe far pensare però ad un pesante restauro del portale stesso, forse in parte ritoccato anche in epoca ottocentesca.[90]

Fig. 43 Left base of the portal, with the initials "L.M.," Palazzo Basso Della Rovere, Savona.

Fig. 44 Right base of the portal, with the date "1690," Palazzo Basso Della Rovere, Savona.

In fact, there are some clear incongruities in the via Pia portal. Although the motif of grape vine shoots in the curved segments is identical to that found elsewhere on the portal, the curved segments themselves and the three diamond-point ashlars set between them introduce a language wholly extraneous to Ligurian portals from the Renaissance and can definitely be considered to be the result of a later transformation.[91]

The date "1690" carved on the base of the right jamb provides a chronological foothold for the alteration of the via Pia portal, also rendering the transformation of the door into an arch stylistically likely. The initials "L. M." at the base of the left jamb might instead be those of the person who ordered the transformation of the portal, a certain L. Multedo, whose family, as we have seen, owned the building since at least the early seventeenth century (fig. 43, fig. 44).[92] The jambs and bases of the via Pia portal are therefore original, never moved from their fifteenth-century location. I can in fact now dispel my initial reservations about the originality of these jambs.[93] Normally, the coils of the vertical cordons of a frame spiral upwards towards the outside of the composition. In the via Pia portal, however, the parallel cordons of both jambs spiral to the left, which initially cast suspicion on the right jamb, held to be a poor copy of the original.[94] And yet, a similar arrangement of parallel cordons is found in the monumental marble portal of the parish church of San Bernardo Abate in the municipality of Stella in val Sansobbia, just outside Savona (fig. 45).[95] Published by Massimo Bartoletti, this intriguing late-fifteenth-century sculptural element is of unknown provenance and was only installed in its current location in about 1789, its place within the Della Rovere circle declared by the numerous acorns included in the cornucopia-motif

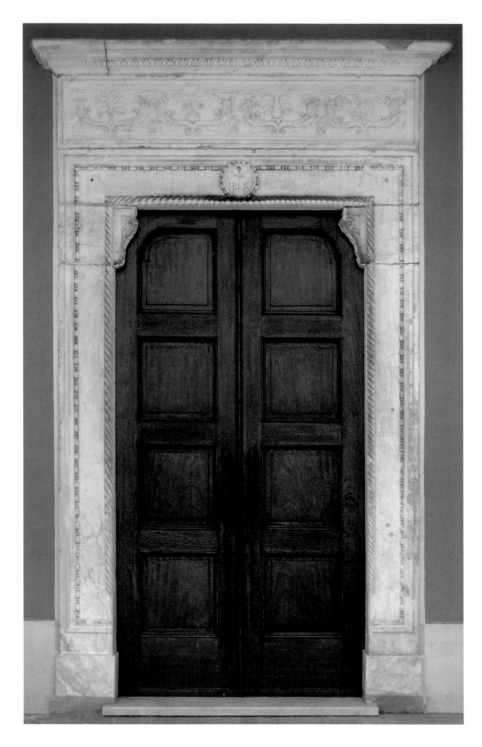

Fig. 45 Portal, marble, second half of the 15th century, parish
church of San Bernardo, Stella (Savona), (published in Bartoletti
2009, p. 44, fig. 3).

frieze. Without getting into the issue of its original location, what interests us here is that it has the same cordon arrangement, which, however outmoded and awkward, has to be considered original. In terms of their dimensions, the Acton overdoor and the jambs of the via Pia portal are precisely compatible down to the centimeter. The virtual reconstruction of the door also reveals its resemblance to the Boston portal,[96] which can thus serve as a model for reconstructing some of the lost elements, like the consoles and the horizontal section of the cornice above them (fig. 46).[97]

Like the portal of Palazzo Spinola in Piazza Pellicceria in Genoa, the two Savona portals are united by a stylistic gap between the refined plasticity of the overdoor and the dry line of the jambs, with their "over-stylized," vaguely early-Christian tendrils. It is also significant that Apuan marble was chosen for the material, marking a turn away from the local black stone from Promontorio and, at the same time, a declaration of magnificence that anticipates the most important sculptural commissions in Savona during the final quarter of the fifteenth century. Put back in its original context of Palazzo Basso Della Rovere, in the middle of a network of papal insignias on monumental marble *tondi* displayed in the city's key locations (Sixtus IV and Julius II *tondi* in Piazza della Maddalena, Sixtus IV *tondo* in the apse wall of the Cappella Sistina, Julius II *tondo* in Piazza del Brandale), the Acton overdoor also contributes to restoring one of Della Rovere Savona's fundamental identity-forming and symbolic keystones, as well as one of its first and most refined incunabula of Renaissance art.[98]

"Magistri antelami" and "pichapietra"

O ne of the aspects that gives the Acton overdoor such great importance is its difference with respect to the other fifteenth-century overdoors, which were usually carved with devotional scenes and imagery like *St. George and the Dragon*, the *Annunciation*, the *Adoration of the Magi*, the *Resurrection of Lazarus*, the *Agnus Dei*, the *YHS Monogram*, *St. John the Baptist* and other saints, or military or heroic motifs and themes like panoplies, processions, and triumphs. Due to this singularity, and like the monument to Sixtus IV's parents, we might imagine that the design for the Acton overdoor was sent from Rome, probably through the intermediation of Cardinal Girolamo, who did everything in his power to assist the social ascent of his brother.

It seems, however, inevitable that the carving of the portal must be traced to the so-called "magistri antelami" and "pichapietra," that is, sculptors, usually from Lombardy or Ticino, who would have been fully responsible for the choice of the deeply traditional design for the jambs, based on models already established in Genoa and in Savona itself, including the

Boston portal.[99] The latter, which can only be dated based on style, seems clearly to precede the Basso Della Rovere d'Aragona portal. The scene of *St. George and the Dragon* stands out significantly from other contemporary images in this genre, which were still quite elaborate in their epic/chivalric narration and therefore steeped in elements typical of the courtly style favored by International Gothic.[100] Indeed, the relief is marked by strong figurative simplification achieved through the flattening of the modeling and elimination of the background, giving greater prominence to the figures of the lady and the knight on horseback as well as the elaborate coats-of-arms to the sides. The taste for the antique is wholly absent here and there is no attempt to create a perspective view, even lacking recourse to the traditional rocky base used to unify the scene and commonly employed in figured overdoors.[101] With some reservations, I would suggest dating the Boston overdoor to the 1470s, just before the major turn "in direzione classicista, grazie anche alla sinergia di lombardi e romani," that Manuela Villani suggested with reference to the tomb of Sixtus IV's parents.[102]

Although the world of overdoors is one populated by artists who will remain forever anonymous, we can make a few further comparisons that will help us to better recognize the quality of the carving of the Acton overdoor and shed light on the artistic character of its author. The closest work also from Savona is unquestionably the fine overdoor walled into the entrance atrium of Palazzo Pavese-Del Carretto-Pozzobonello. It is a irregular bas relief portraying the *Virgin and Child Enthroned, St. Catherine, St. Mary Magdalen, and Two Armor-clad Supporters*, with volute consoles decorated with putti holding up similar coats-of-arms (fig. 47). The patronage of the work remains to be confirmed, but it might have been the Cuneo family, the palace of which at via Quarda Superiore 13 was destroyed for the construction of via Paleocapa.[103] Manuela Villani saw it as the work of a Lombard artist, possibly formed by the very young Amadeo still tied to the Solari workshop, but nevertheless influenced by the culture of the Gagini and mitigated by frequentation of the workshop of the Aria brothers. The scholar prudently gave him the name "Maestro della Maddalena," in reference to the group's most successful work, the *St. Mary Magdalen* now in front of the high altar in the Savona Cathedral (fig. 48).[104] If we were to accept the "Maestro della Maddalena" as the author of the Acton overdoor, we would also need to acknowledge the stylistic and technical superiority of the Palazzo Cuneo overdoor and consider a slightly later date for the latter. It was in any case a sculptor independent of those working in the Cappella Sistina, as we see from comparison with the monument of the parents of Sixtus IV, which is almost entirely attributable to Michele d'Aria, as well as with other works mentioned in the contract, sculpted by collaborators, such as the lunette originally located in the main entrance to the cloister, now walled above the entrance on the right (fig. 49), and the above-cited *tondo* on the exterior apse wall of the Cappella Sistina (fig. 50).

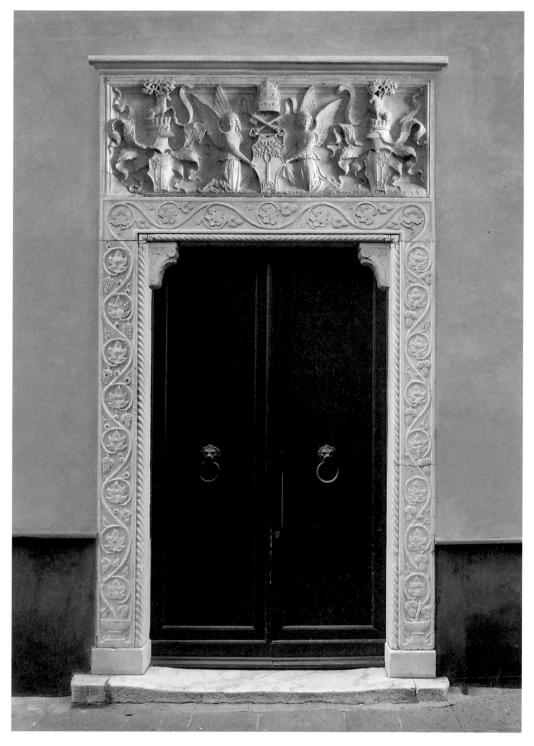

Fig. 46 Digital reconstruction of the Basso Della Rovere
d'Aragona portal.

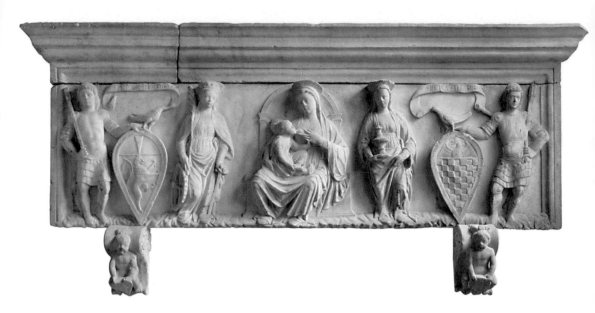

Fig. 47 Maestro della Maddalena, overdoor with the *Virgin and
Child Enthroned, St. Catherine, St. Mary Magdalen, and Two
Squires*, from Palazzo Cuneo, marble, c. 1485, entrance hall of
Palazzo Pavese-Del Carretto-Pozzobonello, Savona.

Fig. 48 Maestro della Maddalena, *St. Catherine*, and *St. Mary
Magdalen,* marble, c. 1480, high altar of the cathedral of Santa
Maria Assunta, Savona. (published in Villani 2006, p. 101, fig. 9)

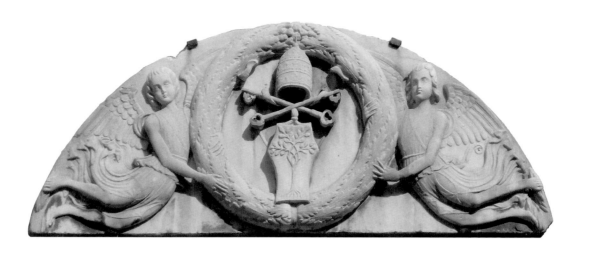

Fig. 49 Michele and Giovanni d'Aria, lunette with *Angels Holding Up the Papal Arms of Sixtus IV*, marble, 1481-1482, side wall of the Cappella Sistina, Savona.

Fig. 50 Michele and Giovanni d'Aria, *Tondo with Papal Arms of Sixtus IV*, marble, 1481-1482, exterior apse wall of the Cappella Sistina, Savona.

"Il bassorilievo in marmo, che vedesi marcato in rosso"

What is certain is that there is oddly no trace of the Acton overdoor whatsoever amidst the city's old epigraphs nor among its oldest civic records. It is also surprising that it escaped the iconoclastic rage of the supporters of the Ligurian Republic (1797-1805), when all of the aristocratic and ecclesiastic insignias were mutilated and abraded with systematic determination.[105] The overdoor also survived unscathed during the demolition of the center of Savona, discussed from 1856 but begun only in 1866, and more remarkably was undamaged by the terrible earthquake on February 23, 1887.[106] The good state of preservation of the work, with sharp corners and well-preserved surfaces, confirms that it was kept safe and in a private space, possibly inside the atrium of Palazzo Basso Della Rovere itself.[107]

A document dated April 25, 1866, reports the reappearance of the overdoor in practically the same place from which it had disappeared. It is a request for authorization to paint and decorate the facades of Palazzo Sacco-Multedo in Piazza della Maddalena, written by the tutor of the under-age marchesa Livia Multedo to the mayor of Savona as president of the city's commission for public works (Commissione Ornato del Comune) (fig. 51). The report reads:

> [...] il tipo dimostrativo delle decorazioni [i.e. the proposed elevation] da eseguirsi nella parte
> del Fabbricato che guarda la suddetta piazza della Maddalena, colla previa osservazione che nel
> resto della casa in via Chiabrera [now via Francesco Spinola] sarà dato un colore liscio verde
> chiaro, uniforme al rimanente edifizio, e senza ornato; e sarà del pari soprapposto al dissotto
> della Galleria il bassorilievo in marmo, che vedesi marcato in rosso nei tipi.[108]

Attached to this document was an elevation signed by the painter Domenico Bruscaglia. This working drawing employs the conventional yellow and red to indicate, respectively, what was to be demolished and what was to be built (fig. 52, fig. 54).[109] The Acton overdoor is referred to as a "bassorilievo" in the report and is clearly illustrated in red ink in the sketch. The plan for the facade envisioned installing the relief in the center of the most important and monumental facade in the piazza (fig. 53), in the middle of the entablature of the Doric order of the ground floor, with the consequential shifting of the window to the side, the old aperture marked in red and the new one in yellow.[110] On July 2 of the same year, the tutor added a further note: "il sottoscritto a maggior decoro e lustro di questa città si sarebbe determinato di fare eseguire in istucco anziché in pittura a fresco gli ornamenti della suddetta parte del fabbricato che guarda la piazza della Maddalena."[111] After years of oblivion and at the height of *Risorgimento* fervor, the proposal to display the Acton overdoor on the facade of Palazzo Sacco-Multedo reveals a new

N.º 75. archivio

Ill.mo Signor Sindaco

Il sottoscritto nella sua qualità di Tutore della Mino-
renne Marchesa Livia Multedo fu Onorio, volendo
decorare con Pittura a fresco il Palazzo Multedo pro-
spiciente in via Chiabrera, e sulla piazza della Madda-
lena in questa Città di Savona, a termini del vigente
Regolamento d'Ornato, Ricorre all'Ill.mo Signor
Sindaco di Città, perché voglia promuovere dalla com-
missione d'Ornato, che tanto degnamente presiede,
la necessaria autorizzazione. _____

Nella lusinga di tanto ottenere, presenta per doppio
il Tipo Dimostrativo delle decorazioni da eseguirsi
nella parte del Fabbricato che guarda la suddetta piaz-
za della Maddalena, colla previa osservazione che
nel resto della casa in via Chiabrera sarà dato un
colore liscio verde chiaro, uniforme al rimanente
edifizio, e senza ornato; e sarà del pari soprapposto
al disotto della galleria il bassorilievo in marmo,
che vedesi marcato in rosso nei Tipi. _____
Savona li 25 aprile 1866. ___
 Il Ricorrente
anzi il sottoscritto a maggior Gavotti Tutore
decoro e lustro di questa Città
si sarebbe determinato di fare eseguire in istucco
anziché in pittura a fresco gli ornamenti della suddetta
parte del fabbricato che guarda la piazza della Maddalena,
e chiede a tale effetto la opportuna autorizzazione.
Savona li 2. Luglio 1866. Il Ricorrente
 Gavotti Tutore

Fig. 51 G. Gavotti, *Relazione*, 1866, *Ornato*, serie III (139/3
Via Pia), Archivio di Stato di Savona.

Fig. 52 Domenico Bruscaglia, elevation of palazzo Sacco-
Multedo, colored inks and washes on paper, 1866, *Ornato,* serie
III (139/3 Via Pia), Archivio di Stato di Savona.

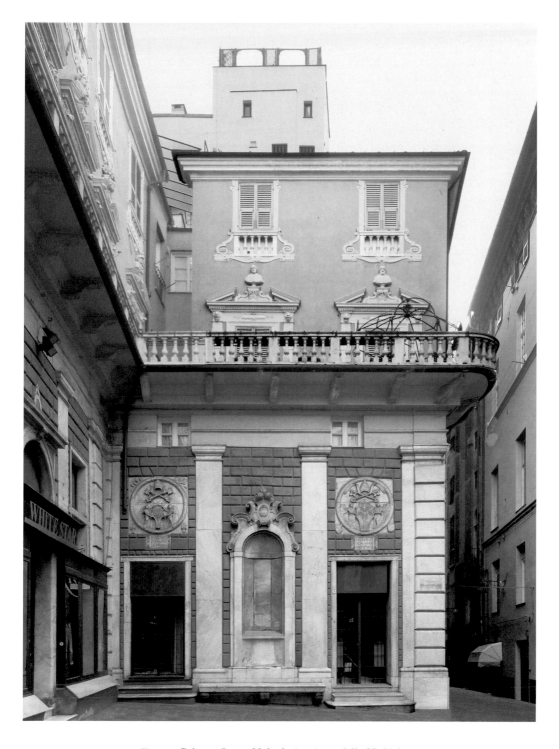

Fig. 53 Palazzo Sacco-Multedo in piazza della Maddalena, Savona.

Fig. 54 Domenico Bruscaglia, detail of the elevation of palazzo
Sacco-Multedo with the Basso della Rovere d'Aragona overdoor,
colored inks and washes on paper, *Ornato,* serie III (139/3 Via
Pia), Archivio di Stato di Savona.

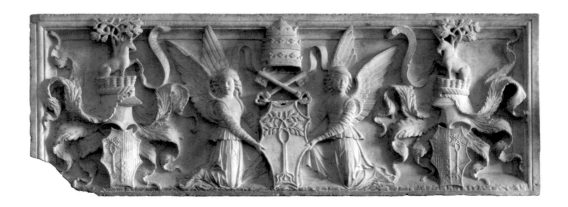

Fig. 55 Basso Della Rovere d'Aragona overdoor, marble, 1479,
Acton Collection, Villa La Pietra, Florence.

way of looking at Della Rovere heraldry, investing it with a civic and identity-forming function. Although this proposal remained confined to the minimal space of an archival drawing, the city of Savona shows that it had understood how to stitch the fragmented memory of its past around that marble relief and tried, through the proposal put forward by the under-age "marchesa Livia Multedo", to display it in the city's most prestigious space, the historic site of the two loggias of the aristocratic class, the location where the two *tondi* dedicated by the city to the two Savona popes had been displayed for centuries, and the place most powerfully infused with memories of the Della Rovere. It was also a way to compensate for the lost monument to the doge Francesco Della Rovere, the empty niche and poignant dedicatory epigraph of which can still be seen today.[112] In the *Guida storica* published in 1874, Nicolò Cesare Garoni indicated that completion of that project for the palace facade was still under consideration:

> Il [palazzo] Multedo in piazza della Maddalena ha una grande facciata maestosa, con un grande terrazzo e due grandi bassorilievi che figurano gli stemmi di Sisto IV e di Giulio II, di cui si vuol collocare la statua in una nicchia dell'intercolunnio di mezzo e altri ornamenti.[113]

The Acton overdoor needs to be imagined most of all among these "other ornaments" (fig. 55). However the plan to monumentalize the facade of Palazzo Sacco-Multedo with the magnificent bas relief made at the time of Sixtus IV remained on paper. Soon Livia Multedo, or her heirs, must have decided to transfer ownership of the work.[114] These is the moment in which it is likely to have entered the antiquarian market and perhaps, for some time, it shared the same fate as the Boston portal, finally arriving at the height of World War I at its current location in Villa La Pietra as part of the Acton collection.

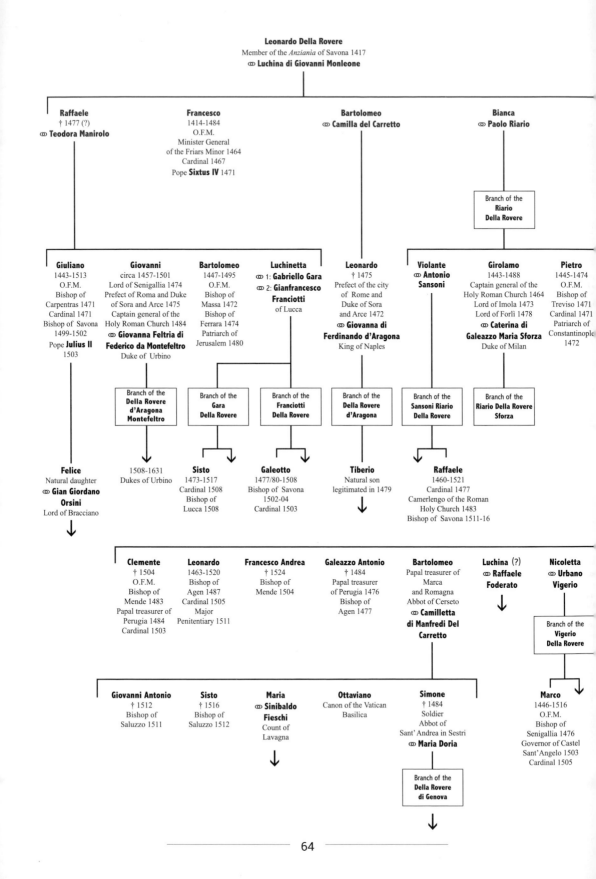

Leonardo Della Rovere
Member of the *Anziania* of Savona 1417
⚭ **Luchina di Giovanni Monleone**

Raffaele
† 1477 (?)
⚭ **Teodora Manirolo**

Francesco
1414-1484
O.F.M.
Minister General
of the Friars Minor 1464
Cardinal 1467
Pope **Sixtus IV** 1471

Bartolomeo
⚭ **Camilla del Carretto**

Bianca
⚭ **Paolo Riario**

Branch of the
**Riario
Della Rovere**

Giuliano
1443-1513
O.F.M.
Bishop of
Carpentras 1471
Cardinal 1471
Bishop of Savona
1499-1502
Pope **Julius II**
1503

Giovanni
circa 1457-1501
Lord of Senigallia 1474
Prefect of Roma and Duke
of Sora and Arce 1475
Captain general of the
Holy Roman Church 1484
⚭ **Giovanna Feltria di
Federico da Montefeltro**
Duke of Urbino

Bartolomeo
1447-1495
O.F.M.
Bishop of
Massa 1472
Bishop of
Ferrara 1474
Patriarch of
Jerusalem 1480

Luchinetta
⚭ 1: **Gabriello Gara**
⚭ 2: **Gianfrancesco
Franciotti**
of Lucca

Leonardo
† 1475
Prefect of the city
of Rome and
Duke of Sora
and Arce 1472
⚭ **Giovanna di
Ferdinando d'Aragona**
King of Naples

Violante
⚭ **Antonio
Sansoni**

Girolamo
1443-1488
Captain general of the
Holy Roman Church 1464
Lord of Imola 1473
Lord of Forlì 1478
⚭ **Caterina di
Galeazzo Maria Sforza**
Duke of Milan

Pietro
1445-1474
O.F.M.
Bishop of
Treviso 1471
Cardinal 1471
Patriarch of
Constantinople
1472

Branch of the
**Della Rovere
d'Aragona
Montefeltro**

Branch of the
**Gara
Della Rovere**

Branch of the
**Franciotti
Della Rovere**

Branch of the
**Della Rovere
d'Aragona**

Branch of the
**Sansoni Riario
Della Rovere**

Branch of the
**Riario Della Rovere
Sforza**

Felice
Natural daughter
⚭ **Gian Giordano
Orsini**
Lord of Bracciano
↓

1508-1631
Dukes of Urbino
↓

Sisto
1473-1517
Cardinal 1508
Bishop of
Lucca 1508
↓

Galeotto
1477/80-1508
Bishop of Savona
1502-04
Cardinal 1503
↓

Tiberio
Natural son
legitimated in 1479
↓

Raffaele
1460-1521
Cardinal 1477
Camerlengo of the Roman
Holy Church 1483
Bishop of Savona 1511-16
↓

Clemente
† 1504
O.F.M.
Bishop of
Mende 1483
Papal treasurer of
Perugia 1484
Cardinal 1503

Leonardo
1463-1520
Bishop of
Agen 1487
Cardinal 1505
Major
Penitentiary 1511

Francesco Andrea
† 1524
Bishop of
Mende 1504

Galeazzo Antonio
† 1484
Papal treasurer
of Perugia 1476
Bishop of
Agen 1477

Bartolomeo
Papal treasurer of
Marca
and Romagna
Abbot of Cerseto
⚭ **Camilletta
di Manfredi Del
Carretto**

Luchina (?)
⚭ **Raffaele
Foderato**
↓

Nicoletta
⚭ **Urbano
Vigerio**
↓

Branch of the
**Vigerio
Della Rovere**

Giovanni Antonio
† 1512
Bishop of
Saluzzo 1511

Sisto
† 1516
Bishop of
Saluzzo 1512

Maria
⚭ **Sinibaldo
Fieschi**
Count of
Lavagna
↓

Ottaviano
Canon of the Vatican
Basilica

Simone
† 1484
Soldier
Abbot of
Sant'Andrea in Sestri
⚭ **Maria Doria**

Marco
1446-1516
O.F.M.
Bishop of
Senigallia 1476
Governor of Castel
Sant'Angelo 1503
Cardinal 1505
↓

Branch of the
**Della Rovere
di Genova**
↓

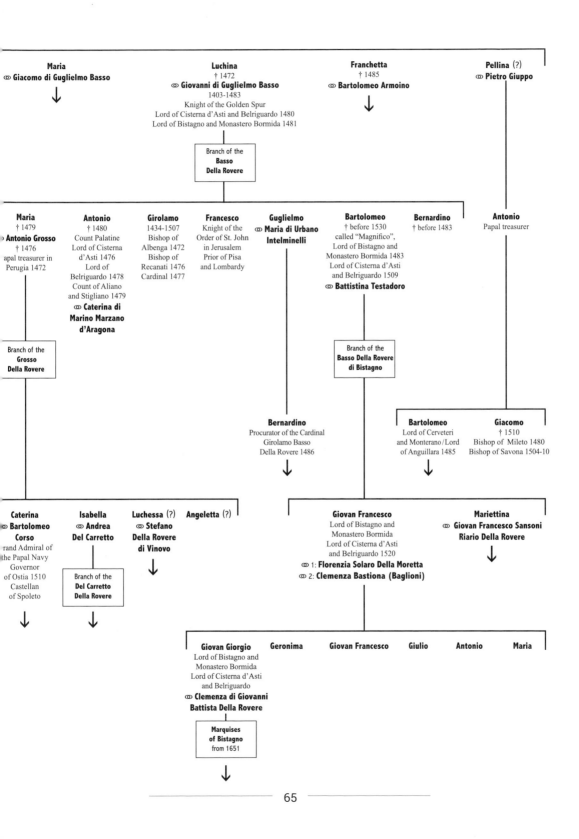

Maria
⚭ **Giacomo di Guglielmo Basso**
↓

Luchina
† 1472
⚭ **Giovanni di Guglielmo Basso**
1403-1483
Knight of the Golden Spur
Lord of Cisterna d'Asti and Belriguardo 1480
Lord of Bistagno and Monastero Bormida 1481

Branch of the
**Basso
Della Rovere**

Franchetta
† 1485
⚭ **Bartolomeo Armoino**
↓

Pellina (?)
⚭ **Pietro Giuppo**

Maria
† 1479
⚭ **Antonio Grosso**
† 1476
apal treasurer in
Perugia 1472

Branch of the
**Grosso
Della Rovere**

Antonio
† 1480
Count Palatine
Lord of Cisterna
d'Asti 1476
Lord of
Belriguardo 1478
Count of Aliano
and Stigliano 1479
⚭ **Caterina di
Marino Marzano
d'Aragona**

Girolamo
1434-1507
Bishop of
Albenga 1472
Bishop of
Recanati 1476
Cardinal 1477

Francesco
Knight of the
Order of St. John
in Jerusalem
Prior of Pisa
and Lombardy

Guglielmo
⚭ **Maria di Urbano
Intelminelli**

Bernardino
Procurator of the Cardinal
Girolamo Basso
Della Rovere 1486
↓

Bartolomeo
† before 1530
called "Magnifico",
Lord of Bistagno and
Monastero Bormida 1483
Lord of Cisterna d'Asti
and Belriguardo 1509
⚭ **Battistina Testadoro**

Branch of the
**Basso Della Rovere
di Bistagno**

Bartolomeo
Lord of Cerveteri
and Monterano/Lord
of Anguillara 1485
↓

Giacomo
† 1510
Bishop of Mileto 1480
Bishop of Savona 1504-10
↓

Bernardino
† before 1483

Antonio
Papal treasurer

Caterina
⚭ **Bartolomeo
Corso**
rand Admiral of
the Papal Navy
Governor
of Ostia 1510
Castellan
of Spoleto
↓

Isabella
⚭ **Andrea
Del Carretto**

Branch of the
**Del Carretto
Della Rovere**
↓

Luchessa (?)
⚭ **Stefano
Della Rovere
di Vinovo**
↓

Angeletta (?)

Giovan Francesco
Lord of Bistagno and
Monastero Bormida
Lord of Cisterna d'Asti
and Belriguardo 1520
⚭ 1: **Florenzia Solaro Della Moretta**
⚭ 2: **Clemenza Bastiona (Baglioni)**

Mariettina
⚭ **Giovan Francesco Sansoni
Riario Della Rovere**
↓

Giovan Giorgio
Lord of Bistagno and
Monastero Bormida
Lord of Cisterna d'Asti
and Belriguardo
⚭ **Clemenza di Giovanni
Battista Della Rovere**

Marquises
of Bistagno
from 1651
↓

Geronima

Giovan Francesco

Giulio

Antonio

Maria

Notes

1. The present study is a significant expansion, with notes and bibliography, of Mussolin 2013, which I will refer to here just once. The city map of Savona and the digital reconstructions are by Leonardo Pili to whom I am deeply indebted. My most sincere thanks are extented to New York University Florence and those who kindly supported this publication, including Francesca Baldry, Barbara Bonciani, Lisa Cesarani, Elisabetta Clementi, Perri Klass, Linda Mills, Larry Wolff, and, most of all, my friend Bruce Edelstein, who chose this text as the first in the Acton Collection Series. This study benefited from research funds provided by the Scuola Normale Superiore, Pisa and New York University Florence. For their generous assistance and for discussing many aspects of this project with me, I am especially grateful to Luigi H. Borgia, Francesco Caglioti, Matteo Chirumbolo, Clario Di Fabio, Maria Falcone, Richard Goldthwaite, Machtelt Isräels, Elizabeth Molina, Marco Ricchebono, Alessandro Savorelli, Nathaniel Silver, Luce Tondi, Carlo Varaldo, and Alessandro Viscogliosi. In Savona, I would like to thank Marco Genzone, director of the Biblioteca Civica, Roberto Granata from the Archivio Storico del Comune, Aurora Rossi from the Archivio di Stato, don Domenico Venturetti, rector of the Museo della Basilica di Nostra Signora di Misericordia del Santuario, Sarah Pagano from the Archivio Diocesano di Savona-Noli, Mauro Costa from the Cappella Sistina, Marco Genta from the Pinacoteca Comunale, Sonia Pedalino from the Confraternita di Santa Maria di Castello, and Anna Maria Porazzo Serafini and Marco Serafini from Amministrazione Serafini, the owner and administrator of Palazzo Basso Della Rovere. During the final phases of production of this volume, Clara Altavista passed away. We had worked closely together for over twenty years, in which I learned so much from her friendship, her scholarship and her example. Naturally, our project to publish together a volume on Savona in the Renaissance is for the moment suspended.

2. For a detailed analysis of the heraldry of the coats-of-arms, see below.

3. New York University Florence, Acton Collection, inv. no. IX.C.4. The documentation regarding the existence of this work in the Acton Collection comes from the photographic archive. No other indications are currently

4. available. The sculpture's provenance through the nineteenth century is however reconstructed below.

4. Luigi Reali's photography studio, Foto Reali, which was located in Florence at via de' Serragli 112 between the late nineteenth century and the 1940s, was specialized in reproductions of works of art in private collections on the antiquarian market. The Foto Reali Archive of more than 3,300 images was digitized by the National Gallery of Art, Washington and can be partially consulted online. The photograph of the Acton overdoor in this archive is listed as located at Villa Acton, attributed to Domenico Gagini, and dated 1450-1500. There is a reproduction of Reali's negative in the Photo Archive of the Kunsthistorisches Institut in Florenz - Max Plank Institut, inv. no. 224667 that entered the collection in 1967 and is contained in the file "Villa La Pietra" in the box "Renaissance Sculpture, Florenz Umgebung".

5. Varaldo 1978, 152, cat. no. 182. The retouching is clear in the lower-left corner of the relief, where a significant portion of the original marble is missing.

6. On sculpted Ligurian overdoors, see the classic studies in Alizeri 1870-1880, V, 5–130, Suida 1906, 47–62, Gavazza 1959, 176, 181–182, Lightbown 1961, Dellepiane 1967, in particular 55–68, Kruft 1971, Foster 1975, Algeri 1977, Kruft 1978, Gavazza 1980, Boccardo 1981, Boccardo 1981-1982, Boccardo 1983, Bedocchi Melucci 1987, Di Pietro 1987, Tagliaferro 1987, in particular 230–236, Coccoluto 1992, Müller Profumo 1992, 37–107, 119–200, Boccardo 1993, Marchi 1993, 161–221, Olivieri 1999, 52–56, Boato 2005, 104–111, Boccardo 2005, Zurla 2014, 43–53, 69–74, Decri, Parodi, Roascio, Rosatto 2015a, Decri, Parodi, Roascio, Rosatto 2015b. On Savona doors in particular, see Tortoroli 1847, 177–178, Garoni 1874, 251–253, Cervetto 1903, 297–298, Chilosi 1985, Folco 1991, Villani 2006, 89–104, Borghi, Dal Seno 2008, Zurla 2014, 100–101.

7. For an invaluable resource on heraldic semiotics, see the brief but lucid entries by Michel Pastoureau in Massabò Ricci, Carassi, Gentile 1998, 41, 71–72, 157–158, 187–189, 286.

8. Interpretation becomes quite complex as the divisions within a shield increase and requires proven experience.

9. Henceforth, we shall refer solely to heraldic right/left.

10. For the idea that the oak is not uprooted but instead has roots clearly displayed, expressing having taken firm possession, see Bonvini Mazzanti 1983, 11, note 7. For important considerations and useful clarifications concerning the origin of the Della Rovere coat-of-arms, see Conti 2006.

11. The complex and contradictory origins of the Della Rovere family are traced in Rossi 1876-1877, Villeneuve 1887, Savio 1890-1891, 5-7 (which presents an even more complicated picture of family ties), and Bruno F. 1919, 55–57 (which instead offers a more balanced historical vision). The topic of the family's origins was returned to more recently in Di Fonzo 1986, 50–59. For a few important document-based clarifications about the family and in particular Leonardo, father of Sixtus IV, as the peacemaker between the Brandale and Maddalena factions, see Rossi 1876-1877, 324, Varaldo O. 1888a, C-CIV. In the area of genealogical reconstructions, the information relative to the Della Rovere family in Passerini, Litta 1863, plates I–VII was pioneering, and not particularly precise. The best and most up-to-date genealogical information is found in Weber 1999, LXXXV-LXXXVI (annotated bibliography), 333–344 (plates 1-12; for the Basso branch see in particular plates 4 and 7). An old Basso-Basso Della Rovere family tree is found in Pavese Ms. (seventeenth century), c. 50 (new numbering).

12. On Leonardo Della Rovere d'Aragona, see Verzellino ed. Astengo 1885-1891, I, 349–350, and Monti 1697, 351–352, as well as Cherubini 1989, Bruzzone 1998d, Cherubini 1999-2000, Miretti 2004. In the quartered coat-of-arms of Leonardo Della Rovere d'Aragona, the first and fourth quarters are filled with the Aragon insignias and the second and third with those of the Neapolitan Anjou, as we see in two coats-of-arms in the castle of Isola del Liri (I would like to thank Alessandro Viscogliosi for this important tip and sending images of them). For recent clarification on Leonardo's coat-of-arms, see Conti 2015, 52–53.

13. On Giovanni Della Rovere d'Aragona, see Verzellino ed. Astengo 1885-1891, I, 396–398, Monti 1697, 352–355, Petrucci 1989, Bruzzone 1998b, Bonvini Mazzanti 1983, Bonvini Mazzanti 2004a. The joint patronage of Giovanni Della Rovere d'Aragona and his wife Giovanna Feltria, daughter of Federigo da Montefeltro, is analyzed

in Bonvini Mazzanti 2004b, Bonvini Mazzanti, Miretti 2004 and, with special reference to architecture, Benelli 1998. When Giovanni Della Rovere became united with the Aragonese, his coat-of-arms was identical to that of Leonardo Della Rovere d'Aragona, but after his marriage into the Montefeltro family he filled the third quarter with that family's distinctive gold and blue diagonal bands. For important observations about this coat-of-arms, see Conti 2015, 56–63. There is a coat-of-arms of Giovanni Della Rovere d'Aragona after his marriage to Giovanna Feltria di Montefeltro possibly from Senigallia at the Museo Stefano Bardini, Florence (inv. 245): see Nesi 2011, 149, cat. 550.

14. In the fifteenth century, "Kingdom of Naples" can only be understood as the *Regnum Siciliae citra Pharum*, which is to say the kingdom of Sicily "this side" of the Strait of Messina, and quite distinct from the *Regnum Siciliae ultra Pharum*, with its capital in Palermo and held by the kings of Aragon since the Sicilian Vespers in 1282. The two were united as the *Regnum Utriusque Siciliae* in the person of Alfonso I the Magnanimous but the union was limited to his reign (1443–1458). When he died, the crowns were once again divided. That of Naples went to his illegitimate son Ferdinand I, also known as Don Ferrante, and that of Sicily went to his brother John II the Great.

15. On Antonio Basso Della Rovere d'Aragona see the entry in the *Dizionario Biografico degli Italiani* 1965, 151–152 as well *Nipoti di Sisto IV* 1868, 679–680, Verzellino ed. Astengo 1885-1891, I, 358–359, D'Almeida 1992a.

16. In heraldry, the saltire is a St. Andrew's Cross made up of a bend and a bend sinister.

17. Schmarsow 1886, 30, passage cited and translated in Pastor 1900, 232: "over all of whom the oak spread its branches, so that the golden fruit fell into their laps."

18. Palazzo Marzano as we see it today has been significantly modified and appears to have been partially rebuilt. See Filangieri di Candida 1947-1951, fig. IV (reference to the coat-of-arms on page 37), Rosi 1979, Miraglia 2011. The coat-of-arms of Marino in the Santa Marta codex is described in Filangieri 1950, 50–51. For more up-to-date information about the codex, see Toscano 1998, 330–331, Leone de Castris 2002.

19. In Verzellino 1621, c. 5, the "Bassarovere" coat-of-arms is described in simplified terms as "una banda e una sbarra incrociate abbassate: sul tutto la quercia rovere". The Della Rovere coat-of-arms with just the uprooted oak is found at c. 3, no. 2. For a detailed analysis of this important text on Savona heraldry, see Bigatti 1966. For a description of a later development of the Basso arms with a "capo d'argento alla croce di rosso: abbassato sotto il capo d'oro caricato d'un'aquila di nero", see Noberasco 1923, 187.

20. Della Chiesa 1655, 28, and Della Chiesa 1777, 16; for the treatise, see Chiara Cusano's entry in Massabò Ricci, Carassi, Gentile 1998, 182.

21. "In *Fiori di blasoneria*, we read: gold with two opposing blue points. In this case, there should only be a short distance between the two points", Manno 1906, 196, note a. The Della Rovere metals and tinctures, well-known to be a gold oak on a blue ground, are reversed in *Fiori di blasoneria*. If not a simple mistake by the author, the inversion of the colors might allude to an explicit homage of the Basso, inverting their metals after their entrance into the papal family. This lies outside analysis of the Acton overdoor, however, due to the total absence of traces of pigment on its marble surface.

22. The Basso Della Rovere coat-of-arms appears frequently in the basilica of Loreto, for example in the keystones of the two famous sacristies with frescoes by Melozzo da Forlì and Luca Signorelli, on the marble basin sculpted by Benedetto da Maiano, and on the side portal on the right of the church (Gardelli 1993, 93, plate XXXI). A similar shield can be seen on a marble *tondo* preserved in the Museo Stefano Bardini, Florence (inv. 169), Nesi 2011, 57. A linen chest decorated with Girolamo's cardinal coat-of-arms went up for auction at the Galleria Longari, Milan in October 2010.

23. For important observations on the origin of the royal coat-of-arms of Aragon, see Pastoureau 1980, Savorelli 1999, Borgia 2001, Conti 2015.

24. In 1420, Joanna II, queen of Naples (sister and heir of the king of Naples and Hungary, Ladislas of Anjou-Durazzo), chose Alfonso V, who was already king of Aragon and Sicily, as her heir, naming him Duke of Calabria, the title specific to the hereditary prince, in exchange for his military aid against Louis III of Anjou (who had been designated Ladislas's heir in 1417). Joanna quickly

renounced her adoption of Alfonso, however, returning to favor Louis III of Anjou. When Louis died, Joanna choose his brother René of Anjou as her heir, and he held the throne as titular king of Naples from 1435 to 1442. Rejecting this controversial succession, Alfonso V fought long to conquer the kingdom, finally succeeding in 1443 and becoming the head of the Neapolitan Aragonese as Alfonso I, holding the throne until his death in 1458. The last exponent of this line was Ferdinand, duke of Calabria (the oldest son of King Frederick I), who died in 1550 as Viceroy of Valencia.

25. The alternating position of the quarters is clear in the coins minted during their reigns. See *Corpus Nummorum Italicorum* 1940, plates IV-IX, as well as Conti 2015, 53–54.

26. Customarily, when a coat-of-arms is repeated in the internal partitions of a quartered shield, this is done respecting its canonical sequence. In our case, relative to the Neapolitan tierced in pale, this order should be Hungary, Anjou, Jerusalem. What we have instead, and appearing twice, is the non-canonical sequence Jerusalem, Anjou, Hungary, due to the specular symmetry of the two side arms and the central symmetry of the two quartered shields. This anomaly seems to derive from the sculptor taking the request for specularity too literally, the result being compositional hypercorrection. In Conti 2015, 61, similar anomalies are noted in some coats-of-arms of Giovanni Della Rovere d'Aragona carved into the capitals of the fortress of Senigallia.

27. On Giovanni di Guglielmo Basso Della Rovere, see Pavese Ms. (seventeenth century), c. 24v, Verzellino ed. Astengo 1885-1891, I, 368–369, Bruzzone 1992. According to Milazzo 2002, 21, a certain Giovanni Basso, in all likelihood Antonio's father, obtained the chapel of San Saturnino (or San Surlino) in emphyteusis on September 13, 1453 for twenty-nine years, along with the two annexed villas in Folconi, west of the city, in an area where two other Della Rovere villas are known to have been located during that period.

28. For a general history of Savona in the fifteenth and sixteenth centuries, see the classic Noberasco, Scovazzi 1926-1928, reissued in a significantly updated version in Noberasco, Scovazzi 1975, I, 103–116, Varaldo 1980, Cerisola 1982, 181–187. For an up-to-date

critical account of the ruling class in Savona and the political rise of the Della Rovere, unencumbered by modern historiographic clichés, see Varaldo 1983, Varaldo 1985, Musso 1995b, 28–50, Musso 1998, Musso 2001, 97–116, Assereto 2007, 15–38. For a convincing critical revision of the concept of the "Della Rovere revival," see Nicolini 2009b, 46–53.

29. The diplomatic mission is mentioned in Poggi V., Poggi P. 1935, 38, 42, 44. On Luchina Della Rovere, see Verzellino ed. Astengo 1885-1891, I, 393, Bruzzone 1992, 421.

30. It seems that Giovanni's brother Giacomo di Guglielmo later married the pope's other sister, Maria, but the information we have about this marriage from the sources at present is scant and quite contradictory. See Passerini, Litta 1863, plate I, Abate ed. Assereto 1897, 235, Bruno F. 1919, 56.

31. Guasco 1911, 241, 1033, Giana 2002 (which reports the date of the purchase of the fief as 1491).

32. On the celebrated and better-studied Girolamo Basso Della Rovere, see Verzellino ed. Astengo 1885-1891, I, 412–414, Monti 1697, 329–331, De Caro 1970, D'Almeida 1992b. On Girolamo Basso Della Rovere's patronage in the Casa Santa di Loreto, see Renzulli 2002, whom I would like to thank for providing clarifications and sharing a few unpublished documents.

33. On Francesco Basso Della Rovere, see Verzellino ed. Astengo 1885-1891, I, 393.

34. On Maria Intelminelli, wife of Guglielmo Basso Della Rovere, see Verzellino ed. Astengo 1885-1891, I, 400. Guglielmo's son was Bernardino, in 1486 procurator of Cardinal Girolamo. Bernardino's final testament from 1502 established a bequest for the construction of a chapel in the Carthusian church of Santa Maria di Loreto outside the Savona walls, Verzellino ed. Astengo 1885-1891, I, 370, 398, also documented in Pavese Ms. (seventeenth century), c. 37r. Further information on Bernardino di Guglielmo, generally left out of Della Rovere genealogies, is found in Claretta 1899, 225, note 2.

35. On Bartolomeo Basso Della Rovere, see Verzellino ed. Astengo 1885-1891, I, 405 and, with some inaccuracies, Bruno F. 1919, 56, in which "Bartolomeo brother of Antonio" is listed as a council member of the city of Savona in 1484. Bartolomeo is recorded as "Signore"

in Abate ed. Assereto 1897, 234. A great deal of documentary evidence survives concerning Bartolomeo, starting with the *Manoscritto Zuccarello*, dated 1530, relative to his patronage of a Basso Della Rovere chapel in the cathedral of Priamàr: "Capella fundata per q. dominum Bartholomeum Bassum de Ruvere sub titulo Sancte Marie de Gratia de jure patronatus filiorum et heredum suorum; habet in Comuni Saone LL. 49. Item in una domo in contracta Maxellorum LL. 94,10" (see Scarrone 1970-1971, 299). Bartoletti and Nicolini publish a document, dated October 11, 1491, recording the commission to the sculptor Michele d'Aria from the bishop Pietro Gara to design a chapel based on the model of one founded by Giuliano Della Rovere containing an altarpiece with "figura depicta Marie virginis de gratie cum duobus angelis" (Bartoletti 2009, 30; Nicolini 2009c, 49–50, doc. II). In reality, the chapel referred to in this document was most likely the one founded by Bartolomeo, as noted by Zurla 2014, 59, note 251, who emphasizes the difficulty of interpreting the line "dominum magnificum Iulianum de Ruvere," suggesting that instead of Giuliano the text refers to Giovanni, i.e. Giovanni Basso Della Rovere, Bartolomeo's father, which would link the patronage of the chapel exclusively to the Basso Della Rovere branch. Bartolomeo Basso Della Rovere commissioned numerous other works. Acting as his brother Girolamo's procurator, he arranged for the foundation of a chapel in the church of Santa Chiara in Savona in 1503, with a marble altar executed by Antonio Della Porta, Alizeri 1870-1880, IV, 319, note 1, Varaldo 1974, 145, note 8, Zurla 2014, 100, note 425, 368, doc. 2. Additionally, on April 18, 1497, Bartolomeo and his brothers founded a "capella nuper fabricata in ecclesia Sancti Benedicti Ville Bruxatorum pro anima Johannis De Ruvere olim Bassus" in Albissola Marina, see Bartoletti 2009, 32, note 13. Bartolomeo Basso Della Rovere's son was Giovanni, husband of Florenzia Solaro della Moretta, and in second marriage Clemenza Bastiona (or Baglione), Verzellino ed. Astengo 1885-1891, I, 439; the marchesi Basso Della Rovere di Bistagno branch descended from the latter union (on the family's fiefs, see the following note). It will be helpful at this point to note a few cases of identical names that have led to confusing our Bartolomeo di Giovanni Basso Della Rovere with other family members, keeping in mind that the former's interests never seem to have led him far from Savona. Verzellino already warned of this problem in his "Avviso ai Lettori intorno a' Cognomi Rovere," Verzellino ed. Astengo 1885-1891, II, 405. Numerous individuals named Bartolomeo Della Rovere held ecclesiastical positions, but these are relatively easy to identify, while there is more confusion surrounding those with lay positions: I hope that the summary provided here does not end up adding further elements of ambiguity to the picture. One particularly significant case is that of the important, extremely wealthy Bartolomeo Grosso Della Rovere, regarding whom see the following note.

36. On Maria, see Bruno F. 1919, 56; on Antonio Grosso Della Rovere and his sons the cardinals Clemente and Leonardo, see Teodori 2003a, Teodori 2003b. Antonio's son Bartolomeo Grosso Della Rovere, was the target of nasty barbs in Pierio Valeriano's *De Litteratorum Infelicitate* (Valeriano 1620, 91–93, see Basile 2004, 322) and described in detail in Ferrajoli 1917, 268–277, with a few notes in Teodori 2003b. The *Bullarium Franciscanum* 1949, 306, doc. 676, note 2, records that "Bartolomeo de Riviera olim Grosso Della Rovere" married Camilletta di Manfredi, marquis of Ceva, in 1475 (in Di Fonzo 1986, 56, wrongly identified with Bartolomeo Basso Della Rovere, who married instead Battistina Testadoro). Bartolomeo Grosso Della Rovere might have even been the "messer Bartolomeo da la Rovere" named in the renowned *Letter to Leo X* by Raphael and Baldassarre Castiglione as the person primarily responsible for the destruction of the ancient monuments of Rome, as suggested in Di Teodoro 1994, 21–22, 47–50, whereas in Shearman 1977, 139, note 65 (and repeated in Shearman 2003, 531) this person is identified as Bartolomeo Basso Della Rovere, with some reservations. The same is true for the argument in Frapiccini 2001, 12–14, and Frapiccini 2013, 22, concerning a "Domini Bar[tholomeus] de Ruere sanctissimi domini nostri pape nepotis et provincie Marchie et Romandiole thesaurari," procurator of Girolamo Basso Della Rovere during the early work on the construction of the basilica of Loreto, identified by the scholar as Bartolomeo Basso Della Rovere, brother of Girolamo, on the basis of a document dated April 14,

1477 that describes him as one of the witnesses of the document, published in Grimaldi 1986, 175, doc. LXIII. The patronymic "domino Bartholomeo Antonij" used in the subsequent document on May 20, 1477, Grimaldi 1986, 176, doc. LXIV, suggests however that this is again Bartolomeo Grosso. The "Bartolomeo dalla Rovere scrittore apostolico e tesoriere della Marca d'Ancona" cited for the year 1486 in Verzellino ed. Astengo 1885-1891, I, 371, must therefore be reasonably understood to have been again Bartolomeo Grosso Della Rovere. The situation is complicated by another important individual with the same name, Bartolomeo Giuppo (Giubba) Della Rovere, mentioned simply as "Bartolomeo Della Rovere Signor di Feudo" in Verzellino ed. Astengo 1885-1891, I, 378, who was briefly lord of the fief of Anguillara, but soon had to return it to Carlo di Virginio Orsini in 1495, see Camilli 2013, 725.

37. The castle of Cisterna d'Asti, already united to the destroyed castle of Belriguardo, which had been in former times placed under the control of the bishop of Asti, was taken by Sixtus IV from the rich Asti bankers Martino, Petrino, and Domenico Pelletta, accused of murdering a family member, and – once returned to the control of the Apostolic Chamber after complex legal proceedings – granted to Antonio Basso on May 17, 1476. On July 9, 1478, his lordship over Belriguardo was recognized, as was his *jus-patronatus* over the parish church of San Gervasio e Protasio in Cisterna, ratifying an old privilege reserved for the local feudal lords (*Sommario de documenti* 1727, n.p., doc. nos. 7-8; Battistoni 2002). Around the same time, but not necessarily in connection with the feudal concession, Antonio was also conferred the title of "militi saonensi." After Antonio's death on August 17, 1480, Sixtus IV reassigned the lordship of those castles to Antonio's father, Giovanni, who was already the lord of the fief of Bistagno and Monastero, and, in the hereditary line of succession, his brothers Bartolomeo and Bernardino (*Sommario de documenti* 1727, n.p., doc. no. 11). As we have noted, all of these fiefs ended up in the hands of Bartolomeo, who received confirmation of the lordship of Cisterna from Julius II on April 25, 1509 (*Sommario de documenti* 1727, n.p., doc. no. 12). Leo X then confirmed its passage to Bartolomeo's son Giovan Francesco on May 11, 1520 (*Sommario de documenti*

1727, n.p., doc. no. 14), from whom it then passed to Gian Giorgio, son of Giovan Francesco (*Sommario de documenti* 1727, n.p., doc. no. 58). The fief of Cisterna and Belriguardo was then sold to the captain Torquato Torto of Castelnuovo on August 18, 1559 by Gian Giorgio's sons Bartolomeo and Antonio, for 5,000 gold scudi (*Sommario de documenti* 1727, n.p., doc. no. 59; Battistoni 2002). The Basso Della Rovere retained the fief of Bistagno and Monastero which, elevated to the status of marquisate in 1651, remained in the family as its main noble title until the nineteenth century. See Verzellino ed. Astengo 1885-1891, II, 52. On the complex history of the fief of Cisterna, see the reconstruction in Claretta 1899, 179–184, which renders obsolete all that was written on the basis of Guasco 1911, 203, 241, 594. On the Basso as "Signori di feudi" more generally, see Verzellino ed. Astengo 1885-1891, I, 368, 405, 439, Bruzzone 1992, 422.

38. *Dizionario Biografico degli Italiani* 1965, 151–152.

39. *Diario Romano* 1904, 10. On Jacopo Gherardi "il Volterrano", see Enrico Carusi's *Prefazione* to the *Diario Romano* 1904 as well as Lee 1979, Calonaci 2000.

40. *Diario Romano* 1904, XIII, 8–10.

41. Marino Marzano provided critical support for the military activity of the troops of the duke of Lorraine, John, son of René of Anjou, who were fighting the Aragonese troops throughout the kingdom. Marino's attempt to ensnare Ferdinand, successfully repelled in 1460, is portrayed in the two upper panels of the bronze door of Castelnuovo cast in 1474-1475. Upon his entry into Naples in 1495, Charles VIII of Anjou freed Giovanni Battista in recognition of the loyalty of his family to the French house. On Marino Marzano, see Sardina 2008, in addition to the classic Ammirato 1580, 190-191 (which does not mention Caterina among his daughters).

42. King Ferdinand allotted a benefice of 3,000 ducats per year for the maintenance of the women of the Marzano House, Sardina 2008, 449.

43. *Diario Romano* 1904, 8.

44. *Diario Romano* 1904, 9, note 3 (the small palace on the bank of the Tiber is noted on pages 3, 31–32, 120), Ammannati Piccolomini 1997, II, 551, note 6. On the history of the building, which was later incorporated into that of the cardinal Giovanni Giacomo Schiaffinati,

bishop of Parma, hence the place name via dell'Arco di Parma, see Mariotti 1925, in particular 426, 440–448, as well as the clarifications in Calamari 1932, II, 347–356, and an update in Sperindei 2004, 138. On Cardinal Girolamo Basso Della Rovere's later residence in Palazzo di Sant'Apollinare, previously the home of the Cardinal d'Estouteville, see Sperindei 2004, 147. On Rome at the time of Sixtus IV, see above all Simoncini 2004, I, 161–204 and Cantatore 2014.

45. *Diario Romano* 1904, 21.

46. *Diario Romano* 1904, LXVII, 21–22.

47. *Diario Romano* 1904, 22, note 1, Müntz 1882, 38, note 6, 148.

48. *Diario Romano* 1904, 47, 52. Verzellino ed. Astengo 1885-1891, I, 359 mistakenly reports what was written in Zazzera 1615, I, 271–272, namely that Caterina had a second marriage to Costanzo Sforza, lord of Pesaro, but this was a slip of the pen, and what was meant was Covella, Caterina's sister.

49. *Diario Romano* 1904, 12.

50. Ruysschaert 1984, Ruysschaert 1989, Ruysschaert 1990; Ruysschaert's theory is analyzed in Clark 1990, 85–86, Tumidei 1992, Foschi 1994, 52–53.

51. *Diario Romano* 1904, 106, 121.

52. The endowment, reported in a manuscript preserved in the Archivio Generale Agostiniano, Rome (Brigida 1858, c. 19), is noted in Bandini 1995, 48, note 39. On the chapel more generally, see Passaglia Bauman 2007, 51–54.

53. The hypotheses advanced over the years concerning the attribution of the majolica tiled floor have been quite discordant and will be worth summarizing here, starting with Quinterio [1990], 72–76 (Umbrian or Viterbese production), Gardelli 1993, 87-89 (Pesaro workshop, last quarter of the fifteenth century), Bandini 1995 (ceramicists of various origin, working in Rome around 1484), Moretti 2004, 72–73 (Pesaro workshops around 1484), Gardelli 2007, 112–114 (reasserted attribution to a Pesaro workshop during the last quarter of the fifteenth century), Dressen 2008, 72–75, 365–367 (with reservations, Deruta or Viterbo workshop, 1483–1492), Bandini 2009 (multiple ceramics workshops in Rome during the last decades of the fifteenth century).

54. For the possibility that a few hexagonal tiles with heraldic

Della Rovere imagery preserved in Palazzo Venezia were part of an early Basso Della Rovere commission in Santa Maria del Popolo, see Bandini 1995, 48–49 and Maria Selene Sconci's entry no. 59, in Bernardini, Bussagli 2008, 189.

55. Forcella 1869, 324, no. 1217 (year 1483). The epitaph is also transcribed, with a few inaccuracies, in Verzellino ed. Astengo 1885-1891, I, 368-369.

56. Caglioti 2016a, 142, note 21, Caglioti 2016b, 69-70, with these considerations the scholar clarified his previous attribution to the young Cesare Quaranta (Caglioti 2004, 353, no. 1-2, note 34), resolving a highly complex and contradictory attribution history, as evident in Cavallaro 1981, 79, Pöpper 2009, 252–254. Two *transennae* with the coat-of-arms of the Basso Della Rovere cardinal are now displayed in the church's first chapel entering on the right; their original position in the church is unknown. See Bentivoglio, Valtieri 1976, 76. For the reliefs of the monument and altar, see Tosi 1856, plates CXXIV and CXXVII.

57. For a broader historiographic exploration of the painting cycle, see Angelini 2002, 134–138, Angelini 2005, 522–523, Gualdi 2009, 271–290, in particular 272, note 58.

58. The most in-depth study of the urban history of Savona remains Ricchebono, Varaldo 1982, which is particularly useful for the city in the fifteenth century, 36–40 and 79–81, as well as for the building features of the urban fabric during the Renaissance, 101–128. On this topic, also see Varaldo 1977, Rossini 1979, 97–116, Robba 1990, 15–24, 35–62, Varaldo 1995. Besio 1963, 79-86, 119–132, updated in Besio 1980, 96–115, is also still of use, containing a "Regesto storico topografico di Savona" compiled *ad annum*.

59. On the construction work for the shipyard, see Musso 1995a, Nicolini 2001.

60. For an overview of fifteenth-century economic history, see Varaldo 1980.

61. On the *Cappella Sistina* in San Francesco, see Malandra 1974, Rossini 1989, Rotondi 1989, Rossini 2000, Rossini 2002, 131–138, Rotondi, Rotondi Terminiello 2002, Rotondi Terminiello, Balma, Ferraris 2005. Rossini 2009, 57–64, strongly supports the theory that the architect Baccio Pontelli created a plan for the

building. On the elegiac distich in epigraphic capitals, see Varaldo 1978, 63, n. 32.

62. The tomb was later moved to the left wall of the chapel. The attribution of the monument to the workshop of Andrea Bregno, initially suggested by Venturi 1908, 959, was repeated in Varaldo 1974, 147, thanks to the discovery of a document (published in Malandra 1974), confirming that papal delegates were sent to Savona and that the Aria brothers were hired to do the work. The theory presented in Rotondi 1989 (republished in extended form in Rotondi, Rotondi Terminiello 2002) attributing the design to Melozzo da Forlì received little following. The episode is discussed in Zurla 2014, 243–256, in particular 247, note 121, who notes that the document published in Klapisch-Zuber 1969, 272, doc. 16, dated January 17, 1482, specifically regards the purchase of marble in Carrara for the monument. The monument of Sixtus IV's parents quickly became the model for other commissions in the Della Rovere sphere. The first was the tomb commissioned by the cardinal Raffaele Sansoni Della Rovere for his father Antonio, entrusted to Giovanni d'Aria on February 11, 1490 (published in Alizeri 1870-1880, IV, 202–204, note 1). Originally installed in the presbytery of the church of San Domenico, it is now in fragments and dispersed between the Palazzo dell'*Anziania* (sarcophagus), the atrium of Palazzo Del Carretto-Pavese-Pozzobonello (statues of Saints Peter and Paul), and the church of San Giovanni Battista (fragments reused in the sacristy lavabo), see the reconstructions in Varaldo 1974, 151–152, plates 4-5, Varaldo 1978, 64–65, no. 34, and new observations in Zurla 2014, 249–250. Another was the tomb that Agostino Spinola, bishop of Savona, commissioned for himself in the church of San Domenico, opposite and in direct formal and compositional relation to the above-cited monument of Antonio Sansoni, his relative. Commonly attributed to Giovanni d'Aria, it was actually made by the sculptors Anton Maria Aprile and Giovanni Angelo Molinari in 1522 and it suffered the same fate as the previous work, dispersed between the Museo Archeologico di Savona (sarcophagus with recumbent effigy), the atrium of Palazzo Del Carretto-Pavese-Pozzobonello (central relief), and the altar of the Annunziata in the Basilica di Nostra Signora di Misericordia del Santuario (architectural structure), see

the reconstructions in Varaldo 1974, 152–153, plate III, Varaldo 1978, 79, no. 57, and new observations in Zurla 2014, 250–251.

63. Bartoletti 2013, 106.

64. On the architecture of the palace, which was built between 1495 and 1500, see Besio 1962, Malandra 1974, Fiore 1979, Fiore 1989, Di Dio 1997, Fiore 2002, Fernández 2007, 72–83, Di Dio 2009, Altavista 2013, 69–72, Fiore 2017; on the building more generally and its restoration history, see Bruno A. 1906, Besio 1968b, Di Dio 2003, Falco, Gotta 1990, Di Dio 2009, and the essays in Di Dio 2010. Finally, see Frommel 2014, 184–195 and the documentary appendix edited by Angelo Nicolini, 224–228. The intriguing information that a quantity of marble was sent from Rome to decorate the palace is found in Abate ed. Assereto 1897, 49–50, note 2.

65. On the new construction on the Priamàr Hill, see Scovazzi, Besio 1959, Nicolini 1980, Nicolini 1987, Nicolini 1988, Varaldo 1992, I, 23–30, Massucco 1995, Lavagna 2007, Nicolini 2009a. The well-known description of the cathedral by the notary Ottobono Giordano, written shortly after the Genoese destroyed the buildings on the hill, is discussed in Torteroli 1847, 265–268, Scovazzi, Besio 1959, 31–32, Fadda, Besio 1959, Vivaldo 1970-1971, Cerisola 1982, 226–229, Farris 1999 (for a critical analysis of this source, see Nicolini 2009a, 200–203). On the bishop's palace, Abate ed. Assereto 1897, 214, note 1, Scovazzi, Besio 1959, 42–44, Nicolini 2009a, 223–226, Frommel 2014, 192–195, 224–228. On the cathedral, see Rocca 1872, 3–39, Verzellino ed. Astengo 1885-1891, II, 563–652, docs. C and F, Scovazzi, Besio 1959, 25–36, Massucco 1982, Massucco, Tassinari 1982, Varaldo 2002, 28–56, Venturino 2007, Nicolini 2009a, 219–226, Lavagna 2009, Lavagna 2010, Massucco 2014. On the wooden choir of the cathedral of Nostra Signora del Castello al Priamàr, see the various essays in Bartoletti 2008. We should in any case also note the other earlier works commissioned by Giuliano for the cathedral, including the polyptych painted by Vincenzo Foppa and Ludovico Brea in 1490, now preserved in Santa Maria di Castello (Bartoletti 2013, on which see also Zurla 2014, 59, note 251 and here note 36), the central-plan sacellum decorated with marble begun in 1491 (Bartoletti 2009,

30–32), and the marble tabernacle of the Holy Sacrament by Matteo da Bissone from 1496, now disassembled (Bartoletti 2009, 35–36).

66. The urban renewal of Savona was also propelled by the foundation of the Monte di Pietà in 1479. See Ricchebono 1980, Massa Piergiovanni 1989.

67. On the Brandale complex, with the tower, the residence of the Podestà, and the adjacent *Anzianìa*, see Bruno A. 1888, Bruno A. 1899, Russo 1936, Poggi P. 1936 (with a detailed description of the surviving stone fragments preserved there) and, most importantly, Besio 1968b. For the modernization of the Brandale building (1502-1503) for the arrival of Yves de Alègre, governor on behalf of the king of France, for which Marco d'Oggiono was commissioned to do the paintings and Matteo da Bissone the sculptural decoration, see Alizeri 1870-1880, I, 330–333 and Bartoletti 2009, 39. On Piazza delle Erbe, the site of the old market, see Milazzo 1998, 5–36.

68. On the iconography of Savona at the end of the fifteenth century, see Massucco 1970-1971, Besio 1974, Ricchebono, Varaldo 1982, 183–196. The reconstruction of the plan of old Savona in Bruno F. 1888 is still useful, while the reconstruction of the city around 1530 in 1:1000 scale in Varaldo 1975 remains essential.

69. An extract from this document was published in Bruno F. 1920, II, 122–123: "1481, 23 gennaio in notaro Tomaso de Moneglia; Ambrosio Della Chiesa vende a Giovanni Serexio, procuratore sostituto di Paolo Forte e questi procuratore del fu Antonio Della Rovere *olim* Basso nipote di Giulio II, una bottega di proprietà di esso Ambrogio nella quale si esercitava l'arte di merciaio sita sotto la casagrande del detto Antonio Della Rovere, da lui acquistata dagli eredi del fu Raimondo Vegerio, che Ambrosio Della Chiesa acquistò fino dal 13 gennaio 1475 per istrumento in notaro Pietro Corsaro da Catterinetta vedova di Giovanni Vegerio e da suo figlio Giovanni al prezzo di lire 142, soldi 17 e denari 2 moneta di Genova. L'atto venne fatto nello scagno della casa di esso Ambrosio presenti i testi Raimondino Vegerio, Battista de Opicis e Antonio de Acquino cittadini Savonesi". Unfortunately, my research in the notarial files in the Archivio di Stato di Savona did not unearth the notary Tomaso da Moneglia's original deed.

70. Varaldo 1975, 114, 134 (no. 943, plate VIII). The "Magnifico domino Bartholomeo de ruvere olim basso" also appears as a witness in a document dated January 30, 1501 (modern dating) regarding the creation of the cathedral's intarsia choir, see Varaldo O. 1889, 50.

71. Varaldo 1975, 133-134 (for the purchase agreement see 122, no. 1036), Fiore 1989, 273, note 20. There is also a long description of the *Caratata* in Agostino Abate's chronicle, the author having been one of the *maestri razionali* appointed by the magistracy (Abate ed. Assereto 1897, 119–131). On this fascinating figure, see Paolocci, Molteni 1995.

72. Verzellino ed. Astengo 1885-1891, II, 52 and Pavese Ms. (seventeenth century), c. 41v. On the Multedo family, see Bruno F. 1919, 78–82. On the palace, see the detailed entry "053. Savona. Palazzo Basso Della Rovere, poi 'Giusti-Rosso-Astengo', via Pia, 15," which notes the building's subsequent changes of ownership and can be consulted on the website of the *Segretariato Regionale del Ministero per i Beni e le Attività Culturali per la Liguria*, in the section *Ufficio Valorizzazione Beni Culturali, Elenco Beni Culturali Visitabili*. One of the most important transformations was at the corner of Piazza della Maddalena at the height of the mezzanine level, above the palace's imposing corner pillar in rusticated ashlar, where it was noted in 1776 that the *Our Lady of Mercy Appearing to Antonio Botta* by Domenico Parodi was installed, having been previously located on the demolished gate to the shipyard pier, see Torteroli 1847, 215–216, Milazzo 2009, 413, note 35.

73. The atrium is a rectangular space with a lunette vault that opens onto a barrel-vaulted stair, the path of which proceeds with a 90° rotation continuing to the upper floors. The wall is supported by short Tuscan columns holding up rampant arches. The large covered roof terrace (altana), open to the south and closed on the remaining sides, is still preserved today.

74. On the importance and transformation of via Pia over time, see Fadda, Giusto, Saviozzi 1959-1960. The place-name vico Meystareta is reported in Varaldo 1975, 44, note 95, 120 (1019), 122 (1044). Nothing further is added in the entry "Vico del marmo" in Gallotti 2001.

75. The oldest Renaissance revival in Liguria of this classical spiral motif seems to be the one in the portal of the palace of Brancaleone Grillo, then Serra, at vico delle

Mele 6, Genoa, with an overdoor featuring *St. George and the Dragon*. On the basis of a well-known document from 1457 (published in Alizeri 1870-1880, IV, 150, Cervetto 1903, 251, doc. XI) we know that Giovanni di Andrea da Bissone was commissioned to sculpt the portal of the palace of Giorgio Doria, then Quartara, at piazza San Matteo 14, Genoa, drawing "in omnibus et per omnia" on the portal of Palazzo Grillo. An essay by Cavazzini, Galli 2007, 27, note 107, attributes the portal of Palazzo Grillo-Serra to the Caronesi masters Filippo Solari and Andrea da Carona, moving up the execution to 1448. On this subject, also see Zurla 2014, 44–48, in which a few earlier arguments are re-examined, including Gavazza 1959, 182, Algeri 1977, 69–71, Müller Profumo 1992, 84, 93–100. Following the example of the Grillo portal, the success of the vaguely Tuscan theme of spirals with putti was sealed when it appeared on the frames around the panels with scenes from the life of John the Baptist in the façade of the chapel of the Battista in the Genoa Cathedral, designed by Domenico Gagini and carved between 1448 and 1450, see Caglioti 1998, 72. Other celebrated examples of frames with spiraling vegetal motifs include those on the two portals of the reformed Dominican friary of Santa Maria di Castello in Genoa, commissioned by the brothers Lionello and Manuele Grimaldi Oliva by 1453, see Poleggi 1982, 139–147, and Zurla 2014, 21–23, in particular note 76. The older of the two portals, now installed in the space of the friary's original library (but previously in the passage between the church choir and the current sacristy), was commissioned by the prior Paride Giustiniani in 1448-1449. The author of this work is difficult to indentify due to the absence of putti; additionally its plant-like spirals and vases are so stylized and elegant that they defy any direct comparison with other known examples in the city. In any case, its overall composition is derived from the Palazzo Grillo portal, see Zurla 2014, 30, note 107. The friary's second portal with spirals is in the current sacristy (formerly Cappella Grimaldi, dedicated to Saints Sebastian and Fabian), and is documented as having been carved by Leonardo Riccomanni on designs by Giovanni di Andrea da Bissone formulated in 1452, with a double frame featuring spiraling vines and, in the horizontal section

of the outer frame, playful putti, see Alizeri 1870-1880, IV, 145–147, note 1, Cervetto 1903, 250, doc. X.

76. On the cathedral's *Crucifixion*, see Beatrice Astrua's entry in Calderoni Masetti, Wolf 2012, I, 350–351, in which the work is attributed to a master trained in the same Lombard workshop as Giovanni di Andrea da Bissone. Zurla 2014, 29, note 106, 48, note 204, instead links the Calvi *Crucifixion* to the altarpiece in the Museo di Sant'Agostino (inv. MSA 292), attributing both works to a sculptor working in the sphere of the workshop of Filippo Solari and Andrea da Carona.

77. The portal in black stone from Promontorio entered the collection in 1899 (inv. I E 12), see Schottmüller 1922, XV, plate 44a.

78. Müller Profumo 1992, 84.

79. "Savona – Via Quarda Superiore – Carrara marble portal with the story of St. George flanked by two shields with coats-of-arms. The field bears the initials D. M. The jambs are decorated with intertwined vine shoots, leaves, and bunches of grapes, as in countless portals in Genoa, especially the one on Piazza Pellicceria. The style is that of Giovanni Gaggini", Cervetto 1903, 297.

80. Kruft 1978, 32, fig. 4.

81. When the museum was expanded, this entrance was closed, the portal disassembled and placed in storage and a fiberglass copy installed in its place. The absence of the initials "D.M." seems to exclude identification of the Boston portal as the one described by Cervetto (see above), but I was not able to consult the original fragments of the work, nor see whether any traces survive of the original carved coats-of-arms in spite of the shields' abrasion.

82. I would like to offer my heartfelt thanks to Nathaniel Silver, Associate Curator of the museum collections, for his generous assistance and permission to consult and publish these documents regarding the portal, and to Elizabeth Molina for her invaluable help in facilitating my requests to the Museum.

83. Emilio Costantini's antiquarian gallery was on corso Italia (formerly corso Regina Elena 6) and his activity as a dealer can be dated between 1880 and 1918. On Costantini, see Fehér 2010-2012, 323–325.

84. "One sculpted marble door, with a frieze depicting the allegory of St. George. From Savona, near Genoa, and

dateable to the Doria age (1400). Lit. 8000.00", *List of works purchased on October 6, 1897*, Object files Archive, Isabella Stewart Gardner Museum, Boston.

85. "Marble doorframe found in Savona, and made ~~at the~~ during the Doria family governed Genua. Lit 8,000", (the words "at the" are crossed out in the original), *Accounts related to works purchased on October 6, 1897*, Object files, Archive, Isabella Stewart Gardner Museum, Boston. Another loose sheet in the same file records the final payment for the portal as 7,560 lire, proportionately reduced by a discount of 2,200 lire applied to the total amount.

86. *Invoice dated October 6, 1897*, Object files Archive, Isabella Stewart Gardner Museum, Boston (the first "n" in "Constantini" is crossed out in the original). The initials stand for Isabella Stewart Gardner and the London Bank Brown Shipley & Co. The final amount should be read as 1,541 pounds, 13 shillings, and 4 pence.

87. *Comments by John Pope Hennessy, August 17, 1971*, Object files Archive, Isabella Stewart Gardner Museum, Boston.

88. Rare information about the sculpture, which might have come from the gate to the bridge of the Savona fortress at Priamàr, can be found in Poggi P. 1938, 16, Villani 2006, 89–91, fig. 1.

89. "The portal in Savona at via Pia, 15 has an inscription at the lower right that was probably added later: L.M. 1690. I am unable to explain what the date refers to. In any case, the portal was carved in the fifteenth century", Kruft 1971, 13, note 43, see esp. his figs. 6-7 for a comparison of the stylization of the shoots on the older portal of Santa Maria di Castello in Genoa (see here note 75) and those on the via Pia portal in Savona. For a brief mention of the Boston portal, see Kruft 1978, 32, note 14.

90. "The accentuated emphasis on formal refinement of the decoration of the via Pia portal and its arched shape cast some doubt on its authenticity, at least as a whole. The date '1690' carved at the base of the right jamb could, however, lead one to think that the portal itself was heavily restored, perhaps even in part during the nineteenth century", Villani 2006, 91, note 35.

91. A similar case of a reworked portal can be seen on the parish church of Kalchios on the Greek island of Chios, which is analyzed in detail in Boccardo 2005, 174–175, figs. 6-7, in part. note 24. The scholar also notes the formal similarity between the grape vine shoots on Kalchios portals and those on the via Pia 15 portal in Savona, all of which are characterized by a unique stylistic dryness and accentuated emphasis on formal refinement ("asciuttezza" and "calligrafismo"). The first scholar to discuss the Genoese portals on Chios, which was the main Genoese colony between 1346 and 1566, was Hasluck 1911.

92. One wonders whether the overdoor was removed in order to relieve the palace of the important, noble Multedo family of the coats-of-arms of the previous owners.

93. Mussolin 2013, 249.

94. There are, however, a few small differences in the treatment of the shoots on the two jambs, both in terms of the bunches of grapes and the venation of the vine leaves, which might be due to two different hands working within the same workshop. It also needs to be pointed out that the right jamb has aged differently, marred by a deep fissure 122 centimeters from the ground.

95. Bartoletti 2009, 40–41, figs. 3-4.

96. The general measurements of the Stewart Gardner portal are: 405 x 222 cm, jambs including base 292 x 28 cm, overdoor with cornice 79 x 222 cm. The general measurements of the (digitally reconstructed) Basso Della Rovere d'Aragona portal are: 403 x 222 cm, jambs including base 292 x 33, overdoor with cornice 80 x 224. The measurements of the Boston portal were taken from those provided in the museum's archival documentation. The measurements of the Savona portal were taken by myself.

97. Unlike the Stewart Gardner portal, in which the consoles were made out of separate blocks and set on top of the jambs, those of the Basso Della Rovere d'Aragona portal were part of the marble blocks used for the jambs, similar to the portal in the Bode-Museum and that of Palazzo Spinola at piazza Pellicceria 3, Genoa. This means that when the curved arch was added, they must have been cut away, as we can see from the abrasions clearly visible at that height.

98. The two popes were elected, respectively, in August 1471 and November 1503, see Verzellino ed. Astengo 1885-1891, II, 334. Relative to the two *tondi* of piazza della Maddalena, Varaldo 1978, 60–61, no. 26 (Sixtus

IV), 69–70, no. 42 (Julius II), highlights the reversal with respect to the commemorative inscriptions below. The provenance of the Brandale plaques dedicated to Julius II, one outside, the other inside the *Anziania*, is unknown, Varaldo 1978, 68–69, nos. 40-41, and do not correspond to the Brandale *tondo* dedicated to Julius II.

99. The Antelami masters came from the Val d'Intelvi, in the area of Lake Como and Lake Lugano. On the Antelami and *pichapietra* from Lombardy in Liguria, see Gavazza 1959, Ciciliot 2006, Villani 2006, Villani 2007, and, more extensively, Zurla 2014, 7–118.

100. The list of overdoors in Savona depicting *St. George and the Dragon*, includes, besides the one in Boston, those of Palazzo Gavotti, possibly originally from the fortress (Poggi P. 1938, 16, and Villani 2006, 89–91, fig. 1); Piazza del Vescovado, from via Vaccioli (Villani 2006, 89–91, fig. 2; archival images in Venturi 1924, 248, fig. 229 with street number 18, Ceschi 1949, 259, with street number 12; in both reproductions, the coats-of-arms seem to have fesses, now almost entirely abraded); vico della Mandorla (Cervetto 1903, 297, who notes the presence of Grillo coats-of–arms) and via Quarda Superiore (Cervetto 1903, 297), both lost.

101. For similar simplifications of composition and modeling, see the two overdoors with scenes of the *Annunciation*, dateable to the 1470s, now in Palazzo Gavotti and published in Villani 2006, 94–95, figs. 5-6.

102. "[…] in the direction of classicism, thanks in part to the synergy between Lombards and Romans", Villani 2007, 35.

103. Bruno A. 1889-1890, XIV-XV, no. 2, Cervetto 1903, 298, Kruft 1978, 33, fig. 9–11, Varaldo 1978, 67, no. 38.

104. Villani 2006, 103–105, fig. 11.

105. Milazzo 2009, 415 ff.

106. The nineteenth-century city plans and rules for decoration are discussed in Massa, Russo 1970-1971. For the demolitions planned after the earthquake, see Bruno A. 1889-1890.

107. There is a significant lacuna at the lower left corner, perhaps caused when it was first dismantled.

108. "Proposal drawing for the decoration to be done on the part of the building overlooking the above-said Piazza della Maddalena, noting that the rest of the residence

on via Chiabrera [now via Francesco Spinola] will be painted a smooth light green hue, the same as the rest of the building, and without decoration. Equally, the marble bas-relief, which you see marked in red in the drawings, will be inserted below the gallery", *Relazione* by G. Gavotti, 1866, *Ornato*, serie III (139/3 Via Pia), Archivio di Stato di Savona.

109. A very small image of Bruscaglia's elevation was published in Ricchebono, Varaldo 1982, 28, fig. 36.

110. In the Deputazione Subalpina di Storia Patria, Turin, there is a drawing of Clemente Rovere that shows Piazza della Maddalena in the first half of the nineteenth century, before the reconstruction of Palazzo Sacco-Multedo, see Milazzo 2009, 424, note 75.

111. "[…] for the greater embellishment and luster of the city, the undersigned would like to have the decorations for the above-said part of the building overlooking Piazza della Maddalena made of stucco rather than painted in fresco", from the above-cited *Relazione* by G. Gavotti, 1866, *Ornato*, serie III (139/3 Via Pia), Archivio di Stato di Savona.

112. Francesco Della Rovere, direct heir of a branch of the Basso Della Rovere family, was elected doge of the Republic of Genoa from 1765 to 1767. The statue was installed in 1766 and destroyed during the republican uprising in 1797. For a highly detailed reconstruction of this episode, see Milazzo 2009. The plaque, initially placed on the pedestal of the lost statue and later walled into the niche, reads: "Serenissimo Francisco Mariæ De Ruvere / Genuensis reipublicæ / Principi Optimo / Ciuitas Sauonensis / ipsius auorumque ciuium / non immemor / ponebat / anno salutis. MDCCLXVI", see Torteroli 1847, 220–221.

113. "[Palazzo] Multedo in Piazza della Maddalena has a large, majestic facade, with a large terrace and two large bas-reliefs with the coats-of-arms of Sixtus IV and Julius II, where there is a wish to install the statue in a niche in the middle intercolumnation and other ornaments.", Garoni 1874, 248.

114 Livia Multedo died in 1918 without heirs, after being married to count Carlo Sillano and, in second marriage, to count Marcello Naselli Feo, "e con essa, si crede, siasi estinta in Savona la famiglia Multedo", see Bruno F . 1919, 82.

Bibliography

Manuscripts

Besio 1962
Giovanni Battista Nicolò Besio, *Il palazzo Della Rovere di Savona*, 1962, typewritten ms., Biblioteca Civica di Savona

Brigida 1858
Agostino Brigida, *Lucerna del Ven. Conv. de RR.PP. Agostiniani di Santa Maria del Popolo*, Archivio Generale Agostiniano, Roma

Pavese Ms. (seventeenth century)
Giovanni Battista Pavese, *Sisto IV PP.RR. Restituito alla Sua Patria di Savona et agli antichi splendori di Sua Casa Della Rovere*, ms. IX-III-2-17, Biblioteca Civica di Savona

Verzellino 1621
Giovanni Vincenzo Verzellino [copy by Giovanni Tommaso Belloro (?)], *Armi di Famiglie Savonesi raccolte e poste insieme da Gio. Vincenzo Verzellino. 1621*, microfilm [original lost], Archivio di Stato di Savona

Verzellino (post 1623)
Giovanni Vincenzo Verzellino, *Delle memorie di Savona*, ms. IX-III-6-1, Biblioteca Civica di Savona

Cited works

Abate ed. Assereto 1897
Agostino Abate, *Cronache Savonesi dal 1500 al 1570, accresciute di documenti inediti, pubblicate e annotate da Giovanni Assereto*, Savona, Tipografia T. Bertolotto e C., 1897

Algeri 1977
Giuliana Algeri, *La scultura a Genova tra il 1450 e il 1470: Leonardo Riccomanno, Giovanni Gagini, Michele D'Aria*, «Studi di Storia delle arti», I, 1977, pp. 65–78

Alizeri 1870-1880
Federigo Alizeri, *Notizie dei Professori del Disegno in Liguria dalle origini al secolo XVI*, 6 vols., Genova, Tipografia di Luigi Sambolino, 1870-1880

Altavista 2013
Clara Altavista, *La residenza di Andrea Doria a Fassolo. Il cantiere di un palazzo di villa genovese nel Rinascimento*, Milano, Franco Angeli Editore, 2013

Ammannati Piccolomini 1997
Jacopo Ammannati Piccolomini, *Lettere (1444-1479)*, a cura di Paolo Cherubini, 3 vols., Roma, Istituto Poligrafico e Zecca dello Stato. Libreria dello Stato, 1997

Ammirato 1580
Scipione Ammirato, *Delle famiglie nobili napoletane*, in Fiorenza, appresso Giorgio Marescotti, 1580

Angelini 2002
Alessandro Angelini, *Francesco di Giorgio e l'architettura dipinta a Siena alla fine del Quattrocento*, «Bullettino senese di storia patria», CIX, 2002, pp. 117–183

Angelini 2005
Alessandro Angelini, *Pinturicchio e i suoi: dalla Roma dei Borgia alla Siena dei Piccolomini e dei Petrucci*, in *Pio II e le arti. La riscoperta dell'antico da Federighi a Michelangelo*, a cura di Alessandro Angelini, Cinisello Balsamo, Silvana Editoriale, 2005, pp. 483–553

Assereto 2007
Giovanni Assereto, *La città fedelissima. Savona e il governo genovese fra il XVI e XVIII secolo*, Savona, Cassa di Risparmio di Savona-Daner Elio Ferraris Editore, 2007

Bandini 1995
Giovanna Bandini, *Il pavimento maiolicato della cappella Basso della Rovere in Santa Maria del Popolo a Roma*, in *Le ceramiche di Roma e del Lazio in età medievale e moderna*, atti del convegno di studi (Roma, 6-7 mag. 1994), a cura di Elisabetta De Minicis, 2 vols., Roma, Edizioni Kappa, 1995, II, pp. 38–52

Bandini 2009
Giovanna Bandini, *Il piancito in maiolica della cappella Basso della Rovere*, in *Santa Maria del Popolo. Storia e restauri*, a cura di Ilaria Miarelli Mariani, Maria Richiello, 2 vols., Roma, Istituto Poligrafico e Zecca dello Stato. Libreria dello Stato, 2009, I, pp. 295–306

Barbero, Fiaschini, Massa, Ricchebono, Varaldo 1980
Savona nel Quattrocento e l'istituzione del Monte di Pietà, a cura di Bruno Barbero, Giulio Fiaschini, Paola Massa, Marco Ricchebono, Carlo Varaldo, Savona, Cassa di Risparmio di Savona, 1980

Bartoletti 2008
Il coro ligneo della Cattedrale di Savona, a cura di Massimo Bartoletti, Cinisello Balsamo, Silvana Editoriale, 2008

Bartoletti 2009
Massimo Bartoletti, *Giuliano Della Rovere e la committenza artistica a Savona tra Quattro e Cinquecento: qualche notazione a margine*, in *Giulio II e Savona*, atti della sessione inaugurale del convegno *Metafore di un pontificato. Giulio II (1503-1513)* (Savona, 7 nov. 2008), a cura di Flavia Cantatore, Myriam Chiabò, Maurizio Gargano, Anna Modigliani, Roma, Roma nel Rinascimento, 2009, pp. 27–45

Bartoletti 2013
Massimo Bartoletti, *Il polittico Della Rovere restaurato: un rendiconto e nuove prospettive di ricerca e di studio*, in *Oratorio di Nostra Signora di Castello a Savona. Storia, Opere, Restauri*, a cura di Rossella Scunza, Luce Tondi, Genova, Sagep Editori, 2013, pp. 95–107

Basile 2004
Bruno Basile, *Il De Litteratorum infelicitate di Pierio Valeriano*, «Filologia e Critica», XXIX, 2004, pp. 318–329

Battistoni 2002
Marco Battistoni, *Regione Piemonte. Schede storiche-territoriali dei comuni del Piemonte. Comune di Cisterna d'Asti*, 2002, [online source: Regione Piemonte, consulted 2015]

Bedocchi Melucci 1987
Alberta Bedocchi Melucci, *Teste all'antica in portali genovesi del XV e XVI secolo*, in *La scultura a Genova e in Liguria*, I, *Dalle origini al Cinquecento*, Genova, Cassa di Risparmio di Genova e Imperia, 1987, pp. 251–255

Benelli 1998
Francesco Benelli, *Baccio, Pontelli, Giovanni della Rovere, il convento e la chiesa di Santa Maria delle Grazie a Senigallia*, «Quaderni dell'Istituto di Storia dell'Architettura», n.s., 31, 1998 (1999), pp. 13–26

Bentivoglio, Valtieri 1976
Enzo Bentivoglio, Simonetta Valtieri, *Santa Maria del Popolo a Roma. Con una appendice di documenti inediti sulla chiesa e su Roma*, Roma, Bardi Editore, 1976

Bernardini, Bussagli 2008
Il '400 a Roma. La rinascita delle arti da Donatello a Perugino, catalogo della mostra (Roma, 29 apr.-7 set. 2008), a cura di Maria Grazia Bernardini, Marco Bussagli, 2 vols., Milano, Skira, 2008

Besio 1963
Giovanni Battista Nicolò Besio, *Evoluzione storico-topografica di Savona*, Savona, Tipografia Smilace e Palagi, 1963

Besio 1968a
Giovanni Battista Nicolò, *I castelli del savonese*, Savona, Editrice Liguria, 1968

Besio 1968b
Giovanni Battista Nicolò Besio, *Il Palazzo della Giustizia e l'antico "centro direzionale" del Comune di Savona*, «Atti e Memorie della Società Savonese di Storia Patria», n.s., II, 1968, pp. 45–83

Besio 1974
Giovanni Battista Nicolò Besio, *Savona iconografica*, Savona, Editrice Liguria, 1974

Besio 1980
Giovanni Battista Nicolò, *Savona: il centro storico*, Savona, Siag Editore-Valenti Editore, 1980

Bigatti 1966
Franco Bigatti, *Araldica Savonese: l'armolario verzelliniano (sec. XVII)*, «Tribuna araldica», lug.-dic., 1966, pp. 3–14

Boato 2005
Anna Boato, *Costruire "alla moderna". Materiali e tecniche a Genova tra XV e XVI secolo*, Firenze, Edizioni All'insegna del Giglio, 2005

Boccardo 1981
Piero Boccardo, *Portali e sovrapporte genovesi: manufatto di scultura o arredo urbano?*, «Indice per i beni culturali del territorio ligure», VI, 1981, 5/6, pp. 13–15

Boccardo 1981-1982
Piero Boccardo, *Per l'iconografia*

del *"trionfo" nella Genova del Rinascimento, i portali Doria e Spinola*, «Studi di storia delle arti», IV, 1981-1982, pp. 39–54

Boccardo 1983
Piero Boccardo, *Per una mappa iconografica dei portali genovesi del Rinascimento*, in *La scultura decorativa del Primo Rinascimento*, atti del I convegno internazionale di studi (Pavia, 16-18 set. 1980), Roma, Viella, 1983, pp. 41–53

Boccardo 1993
Piero Boccardo, *Un capitolo della scultura a Levanto nel Quattrocento: le sovrapporte*, in *Le arti a Levanto nel XV e XVI secolo*, catalogo della mostra (Levanto, 26 giu.-3 ott. 1993), a cura di Piero Donati, Milano, Electa, 1993, 38-42 (saggio), 95–110 (schede)

Boccardo 2005
Piero Boccardo, *Marmi antichi e "moderni" sulle rotte fra Genova e Chio*, in *Genova e l'Europa mediterranea. Opere, artisti, committenti, collezionisti*, a cura di Piero Boccardo, Clario Di Fabio, Cinisello Balsamo, Fondazione Carige-Silvana Editoriale, 2005, pp. 167–181

Bonvini Mazzanti 1983
Marinella Bonvini Mazzanti, *Giovanni della Rovere. Un 'principe nuovo' nelle vicende italiane degli ultimi decenni del XV secolo*, Senigallia, Edizioni 2G, 1983

Bonvini Mazzanti 2004a
Marinella Bonvini Mazzanti, *Giovanni Della Rovere*, in *La Quercia dai*

frutti d'oro. *Giovanni della Rovere (1457-1501) e le origini del potere roveresco* (Deputazione di Storia Patria per le Marche. Studi e Testi, Nuova Serie, 22), atti del convegno di studi (Senigallia, 23-24 nov. 2001), a cura di Marinella Bonvini Mazzanti, Gilberto Piccinini, Ancona, Ostra Vetere Tecnostampa, 2004, pp. 11–43

Bonvini Mazzanti 2004b
Marinella Bonvini Mazzanti, *I Della Rovere*, in *I Della Rovere, Piero della Francesca, Raffaello, Tiziano*, catalogo della mostra (Senigallia-Urbino-Pesaro-Urbania, 4 apr.-3 ott. 2004), a cura di Paolo Dal Poggetto, Milano, Electa, 2004, pp. 35–50

Bonvini Mazzanti, Miretti 2004
Marinella Bonvini Mazzanti, Monica Miretti, *Profili*, in *I Della Rovere, Piero della Francesca, Raffaello, Tiziano*, catalogo della mostra (Senigallia-Urbino-Pesaro-Urbania, 4 apr.-3 ott. 2004), a cura di Paolo Dal Poggetto, Milano, Electa, 2004, unnumered inserts between pp. 35–50

Borghi, Dal Seno 2008
Davide Borghi, Catia Dal Seno, *I portali di Savona*, Savona-Milano, Delfino&Enrile Editori, 2008

Borgia 2001
Luigi Borgia, *Lo stemma del Regno delle Due Sicilie*, Firenze, Edizioni Polistampa, 2001

Bottaro, Dagnino, Rotondi Terminiello 1989
Sisto IV e Giulio II mecenati e promotori di cultura, atti del convegno internazionale di studi (Savona, 3-6

nov. 1985), a cura di Silvia Bottaro, Anna Dagnino, Giovanna Rotondi Terminiello, Savona, Soprintendenza per i Beni Artistici e Storici della Liguria-Comune di Savona-Università degli Studi di Genova-Coop Tipograf, 1989

Brugnoli 1967
Maria Vittoria Brugnoli, *Attività delle Soprintendenze: Roma. Chiesa di S. Maria del Popolo. Cappella Della Rovere*, «Bollettino d'arte», s. V, a. LII, 1967, 4, pp. 248–249

Bruno A. 1888
Agostino Bruno, *La torre del Brandale*, «Atti e Memorie della Società Storica Savonese», I, 1888, pp. 393–402

Bruno A. 1889-1890
Agostino Bruno, *Quadro delle principali opere d'arte e d'antichità esistenti nelle fabbriche da demolirsi per il compimento della via Paleocapa*, «Atti e Memorie della Società Storica Savonese», II, 1889-1890, pp. XIII–XIX

Bruno A. 1899
Agostino Bruno, *Il palazzo del Comune*, «Bullettino della Società Storica Savonese», II, 1899, 3/4, pp. 158–167

Bruno A. 1906
Agostino Bruno, *Il cortile del palazzo Della Rovere e gli antichi diritti patrimoniali del Comune di Savona*, in «Bullettino della Società Storica Savonese», VII, 1906, 1, pp. 78–81

Bruno F. 1888
Federico Bruno, *Pianta topografica di Savona nel secolo XVIII*, «Atti e Memorie della Società Storica Savonese», I, 1888, pp. 403–408

Bruno F. 1919
Federico Bruno, *La ricostruzione del "Libro d'Oro" del Comune di Savona. Parte I*, «Atti della Società Savonese di Storia Patria», II, 1919, pp. 43–94

Bruno F. 1920
Federico Bruno, *La ricostruzione del "Libro d'Oro" del Comune di Savona. Parte II*, «Atti della Società Savonese di Storia Patria», III, 1920, pp. 113–156

Bruzzone 1992
Gian Luigi Bruzzone, *Basso Della Rovere, Giovanni*, in *Dizionario biografico dei liguri: dalle origini al 1990*, 1, Genova, Consulta ligure, 1992, pp. 421–422

Bruzzone 1998a
Gian Luigi Bruzzone, *Della Rovere, Bartolomeo*, in *Dizionario biografico dei liguri: dalle origini al 1990*, 4, Genova, Consulta Ligure, 1998, pp. 590–591

Bruzzone 1998b
Gian Luigi Bruzzone, *Della Rovere, Giovanni*, in *Dizionario biografico dei liguri: dalle origini al 1990*, 4, Genova, Consulta ligure, 1998, pp. 596–597

Bruzzone 1998c
Gian Luigi Bruzzone, *Della Rovere, Giovanni Giorgio*, in *Dizionario biografico dei liguri: dalle origini al 1990*, 4, Genova, Consulta ligure, 1998, p. 598

Bruzzone 1998d
Gian Luigi Bruzzone, *Della Rovere, Leonardo*, in *Dizionario biografico dei liguri: dalle origini al 1990*, 4, Genova, Consulta ligure, 1998, pp. 599–600

Bruzzone 1998e
Gian Luigi Bruzzone, *Della Rovere, Luchina*, in *Dizionario biografico dei liguri: dalle origini al 1990*, 4, Genova, Consulta ligure, 1998, pp. 600–601

Bullarium Franciscanum 1949
Bullarium Franciscanum, Nova series, III, *Continens constitutiones epistolas diplomata Romani pontificis Sixti IV ad tres Ordines S.P.N. Francisci spectantia: (1471-1484)*, collegit et edidit fr. Joseph Maria Pou y Martí, 3 vols., Ad Claras Aquas (Quaracchi), Ex Typographia Collegii S. Bonaventurae, 1949

Caglioti 1998
Francesco Caglioti, *Sull'esordio brunelleschiano di Domenico Gagini*, in *Omaggio a Fiorella Sricchia Santoro*, «Prospettiva», 91-92, lug.-ott., 1998, 1, pp. 70–90

Caglioti 2004
Francesco Caglioti, *Due "virtù" marmoree del primo Cinquecento napoletano emigrate a Lawrence, Kansas. I Carafa di Santa Severina e lo scultore Cesare Quaranta per San Domenico Maggiore*, «Mitteilungen des Kunsthistorischen Institutes in Florenz», 48, 2004, pp. 333–358

Caglioti 2016a
Francesco Caglioti, *La connoisseurship della scultura rinascimentale: esperienze e*

considerazioni di un "romanista" mancato, in *Il metodo del conoscitore. Approcci, limiti, prospettive*, a cura di Stefan Albl con Alina Aggujaro, Roma, Editoriale Artemide, 2016, pp. 125–152

Caglioti 2016b
Francesco Caglioti, *Sulla tomba odierna di papa Eugenio IV, già appartenuta a Francisco des Prats, "cardinale di León", e sul suo autore principale, Matteo Pellizzone da Milano*, in *Studi in onore di Stefano Tumidei*, a cura di Andrea Bacchi, Luca Massimo Barbero, Venezia-Bologna, Fondazione Giorgio Cini-Fondazione Federico Zeri, 2016, pp. 62–79

Calamari 1932
Giuseppe Calamari, *Il confidente di Pio II. Card. Iacopo Ammannati Piccolomini (1422-1479)*, con la prefazione di Albano Sorbelli, 2 vols., Roma-Milano, Augustea, 1932

Calderoni Masetti, Wolf 2012
La Cattedrale di San Lorenzo a Genova, a cura di Anna Rosa Calderoni Masetti, Gerhard Wolf, (Mirabilia Italiae, 18,2), 2 vols., Modena, Franco Cosimo Panini, 2012

Calonaci 2000
Stefano Calonaci, *Gherardi, Jacopo*, in *Dizionario biografico degli italiani*, 53, Roma, Istituto dell'Enciclopedia Italiana Treccani, 2000, pp. 573–576

Camilli 2013
Stefania Camilli, *Gentil Virginio Orsini*, in *Dizionario biografico degli italiani*, 79, Roma, Istituto

dell'Enciclopedia Italiana Treccani, 2013, pp. 721–729

Cantatore 2014
Flavia Cantatore, *Sisto IV committente di architettura a Roma tra magnificenza e conflitto*, in *Congiure e conflitti. L'affermazione della signoria pontificia su Roma nel Rinascimento: politica, economia e cultura*, atti del convegno internazionale (Roma, 3-5 dic. 2013), a cura di Myriam Chiabò, Maurizio Gargano, Anna Modigliani, Patricia Osmond, Roma, Roma nel Rinascimento, 2014, pp. 313–338

Cavallaro 1981
Anna Cavallaro, *Introduzione alle cappelle maggiori*, in *Umanesimo e primo Rinascimento in S. Maria del Popolo*, (Il '400 a Roma e nel Lazio, 1), catalogo della mostra (Roma, 12 giu.-30 set. 1981), a cura di Roberto Cannata, Anna Cavallaro, Claudio Strinati, con un intervento di Pico Cellini, Roma, De Luca, 1981, pp. 75–84

Cantatore, Chiabò, Farenga, Gargano *et alia* 2010
Metafore di un pontificato. Giulio II (1503-1513), atti del convegno (Roma, 2-4 dic. 2008), a cura di Flavia Cantatore, Myriam Chiabò, Paola Farenga *et alia*, Roma, Roma nel Rinascimento, 2010

Cantatore, Chiabò, Gargano, Modigliani 2009
Giulio II e Savona, atti della sessione inaugurale del convegno *Metafore di un pontificato. Giulio II (1503-1513)* (Savona, 7 nov. 2008), a cura di Flavia Cantatore, Myriam Chiabò,

Maurizio Gargano, Anna Modigliani, Roma, Roma nel Rinascimento, 2009

Cavazzini, Galli 2007
Laura Cavazzini, Aldo Galli, *Scultori a Ferrara al tempo di Niccolò III*, in *Crocevia estense. Contributi per la storia della scultura a Ferrara nel XV secolo*, a cura di Giancarlo Gentilini, Lucio Scardino, Ferrara, Casa editrice "Liberty house" di Lucio Scardino, 2007, pp. 7–88

Cerisola 1982
Nello Cerisola, *Storia di Savona*, Savona, Editrice Liguria, 1982

Cervetto 1903
Luigi Augusto Cervetto, *I Gaggini da Bissone: loro opere a Genova e altrove. Contributo alla storia dell'arte*, Milano, Hoepli, 1903

Ceschi 1949
Carlo Ceschi, *I monumenti della Liguria e la guerra 1940-45*, Genova, A.G.I.S. Arti Grafiche Ito Stringa, 1949

Cherubini 1989
Paolo Cherubini, *Della Rovere, Leonardo*, in *Dizionario biografico degli italiani*, 37, Roma, Istituto dell'Enciclopedia Italiana Treccani, 1989, pp. 360–361

Cherubini 1999-2000
Paolo Cherubini, *Lettere concistoriali di Eugenio IV e Sisto IV. Nuovi documenti su Leonardo Della Rovere nipote di Sisto IV e prefetto di Roma (con cinque lettere a Lorenzo de' Medici)*, «Bullettino dell'Istituto Storico Italiano per il Medio Evo», 102, 1999-2000, pp. 167–208

Chilosi 1985
Cecilia Chilosi, *I rilievi dei portali;
I tabernacoli; I mausolei rovereschi*,
in *Itinerari rovereschi. Savona nei
secoli XV e XVI*, pubblicazione
realizzata in occasione delle
manifestazioni *Età dei Della Rovere*
in collaborazione con Comune di
Savona e Regione Liguria, Savona,
Stab. Tip. Priamàr, 1985, pp. 12–16

Ciciliot 2006
Furio Ciciliot, *Arte rinascimentale:
Piccapietra et alii magistri (Savona,
1506-1570)*, «Atti e Memorie della
Società Savonese di Storia Patria»,
n.s., XLII, 2006, pp. 143–161

Claretta 1899
Gaudenzio Claretta, *Sulle principali
vicende della Cisterna d'Asti dal
secolo XV al XVIII. Notizio storico-
diplomatica*, «Memorie della Reale
Accademia di Scienze di Torino»,
s. II, XLVIII, 1899, pp. 165–238

Clark 1990
Nicholas Clark, *Melozzo da Forlì
pictor papalis*, London, Sotheby's,
1990

Coccoluto 1992
Giovanni Coccoluto, *Una
sovrapporta quattrocentesca
a La Briga (Alpes-Maritimes)*,
«Sabazia. Quaderni di storia,
arte, archeologia», n.s., 13, 1992,
pp. 18–22

Conti 2006
Antonio Conti, *L'origine dell'arma
dei Della Rovere*, «Pesaro città e
contà. Rivista della Società pesarese
di studi storici», 23, 2006, pp. 7–15

Conti 2015
Antonio Conti, *La prima evoluzione
dell'arma dei Della Rovere: la
generazione di Giovanni signore di
Senigallia*, «Studi Pesaresi. Rivista
della Società pesarese di studi
storici», 3, 2015, pp. 51–69

Corpus Nummorum Italicorum 1940
*Corpus Nummorum Italicorum. Primo
tentativo di un catalogo generale
delle monete medievali e moderne
coniate in Italia e da italiani in
altri paesi*, XIX, *Italia meridionale
continentale. Napoli. Parte 1: dal
Ducato napoletano a Carlo V*, Roma,
Stabilimento Tipografico Ditta Carlo
Colombo, 1940

D'Almeida 1992a
O. D'Almeida, *Basso Della Rovere,
Antonio*, in *Dizionario biografico
dei liguri: dalle origini al 1990*, I,
Genova, Consulta ligure, 1992,
pp. 420

D'Almeida 1992b
O. D'Almeida, *Basso Della Rovere,
Gerolamo*, in *Dizionario biografico
dei liguri: dalle origini al 1990*, I,
Genova, Consulta ligure, 1992,
pp. 420–421

Damiani Cabrini 2018
Laura Damiani Cabrini, *I monumenti
rinascimentali di Savona sotto la
lente di Varni: Andrea da Giona,
Antonio Maria Aprile e i d'Aria*, in
*Santo Varni: conoscitore, erudito e
artista tra Genova e l'Europa*, a cura
di Laura Damiani Cabrini, Grégoire
Extermann, Raffaella Fontanarossa,
Chiavari, Società Economica di
Chiavari, 2018, pp. 25–49

De Caro 1970
Gaspare De Caro, *Basso della Rovere,
Girolamo*, in *Dizionario biografico
degli italiani*, 7, Roma, Istituto
dell'Enciclopedia Italiana Treccani,
1965, pp. 152–153

De Floriani 1995
Anna De Floriani, *Agostino Abate
illustratore. Le illustrazioni dei codici
abatiani conservati presso la Biblioteca
Universitaria di Genova*, in *Giovanni
Agostino Abate. Una fonte per la
storia di Savona nel XVI secolo. Studi
in occasione del quinto centenario
della nascita (1495-1995)*, a cura di
Claudio Paolocci, Ferdinando Molteni,
Genova, Società Savonese di Storia
Patria, 1995, pp. 81–92

Decri, Parodi, Roascio, Rosatto
2015a
Anna Decri, Isidoro Parodi,
Stefano Roascio, Giulia Rosatto,
*Cronotipologia al tempo del web
2.0: banca dati e mappa online dei
portali di Genova*, «Archeologia e
calcolatori», 26, 2015, pp. 265–274

Decri, Parodi, Roascio, Rosatto
2015b
Anna Decri, Isidoro Parodi,
Stefano Roascio, Giulia Rosatto, *La
datazione dei portali genovesi tra
cutura materiale e storia dell'arte*,
in *VII Congresso di archeologia
medievale*, I, *Sezione I. Teoria e metodi
dell'archeologia medievale, Sezione
II. Insediamenti urbani e architettura,
Sezione III. Territorio e ambiente*,
atti del convegno (Lecce 9-12 set.
2015), a cura di Paul Arthur, Marco
Leo Imperiale, Lecce, All'Insegna del
Giglio, 2015, pp. 174–178

Della Chiesa 1655
Francesco Agostino Della Chiesa, *Fiori di Blasoneria per Ornar la Corona di Savoja con i fregi della Nobiltà*, Torino, Per Alessandro Federico Caualieri Libraro di S.A.R., 1655

Della Chiesa 1777
Francesco Agostino Della Chiesa, *Fiori di blasoneria per ornare la Corona di Savoja con i fregi della nobiltà. Esattamente ristampati secondo l'edizione del 1655*, Torino, per Onorato Derossi, 1777 [facsimile ed., Milano, Edizioni Orsini De Marzo, 2014]

Dellepiane 1967
Alberto Dellepiane, *I portali: Genova e Liguria artistica*, Genova, Ed. Realizzazioni Grafiche Artigiane, 1967

Di Dio 1997
Maria Di Dio, *Appunti sulle volte di Giuliano da San Gallo: le due realizzazioni savonesi*, in *Settanta studiosi italiani. Scritti per l'Istituto Germanico di Storia dell'Arte di Firenze*, a cura di Cristina Acidini Luchinat, Luciano Bellosi, Miklòs Boskovits, Pier Paolo Donati, Bruno Santi, Firenze, Casa ed. Le Lettere, 1997, pp. 175–182

Di Dio 2003
Maria Di Dio, *I Francesi e il Palazzo della Rovere di Savona tra XVIII e XIX secolo. Le nuove conoscenze ed i restauri*, in *I Francesi e il Palazzo della Rovere di Savona tra XVIII e XIX secolo*, a cura di Maria Di Dio, Luce Tondi, Savona, Marco Sabatelli Editore, 2003, pp. 19–34

Di Dio 2009
Maria Di Dio, *Il Palazzo Della Rovere di Savona. L'impianto roveresco e le scoperte durante i lavori di restauro*, in *Giulio II e Savona*, atti della sessione inaugurale del convegno *Metafore di un pontificato. Giulio II (1503-1513)* (Savona, 7 nov. 2008), a cura di Flavia Cantatore, Myriam Chiabò, Maurizio Gargano, Anna Modigliani, Roma, Roma nel Rinascimento, 2009, pp. 75–91

Di Dio 2010
Interventi di restauro nel Palazzo della Rovere di Savona, a cura di Maria Di Dio, Genova, Soprintendenza per i Beni Architettonici e Paesaggistici della Liguria-Fratelli Frilli Editori, 2010

Di Fabio 2004
Clario Di Fabio, *Domenico Gagini da Bissone a Firenze e a Genova, con una postilla per suo nipote Elia*, in *Genova e l'Europa continentale, Austria, Germania e Svizzera. Opere, artisti, committenti, collezionisti*, a cura di Piero Boccardo, Clario Di Fabio, Cinisello Balsamo, Silvana Editoriale, 2004, pp. 49–71

Di Fonzo 1986
Lorenzo Di Fonzo, *Sisto IV. Carriera scolastica e integrazioni biografiche (1414-1484)*, «Miscellanea francescana», 86, 1986, 2/4, pp. 1–491

Di Pietro 1987
Manuela Di Pietro, *Tradizione classica a Genova: tipologia dei portali con decorazioni di armi (sec. XVI-XVIII)*, «Bollettino dei Musei Civici Genovesi», IX, 26/27,1987, pp. 11–38

Di Teodoro 1994
Francesco Paolo Di Teodoro, *Raffaello, Baldassar Castiglione e la Lettera a Leone X*, Bologna, Nuova Alfa Editoriale, 1994

Diario Romano 1904
Il Diario Romano di Jacopo Gherardi da Volterra, a cura di Enrico Carusi, in *Rerum Italicarum Scriptores*, Nuova edizione riveduta ampliata e corretta con la direzione di Giosue Carducci e Vittorio Fiorini, Tomo XXIII, Parte III, Città di Castello, coi tipi della casa editrice S. Lapi, 1904

Dizionario biografico degli italiani 1965
Basso Della Rovere, Antonio, in *Dizionario biografico degli italiani*, 7, Roma, Istituto dell'Enciclopedia Italiana Treccani, 1965, pp. 151–152

Dressen 2008
Angela Dressen, *Pavimenti decorati del Quattrocento in Italia*, Venezia, Marsilio, 2008

Fadda, Besio 1959
Mario Fadda, Giovanni Battista Nicolò Besio, *L'itinerario di Ottobono Giordano attraverso il Priamàr e la città (1525)*, in *Il Priamàr*, «Atti della Società Savonese di Storia Patria», XXX, 1959, pp. 61–65

Fadda, Giusto, Saviozzi 1959-1960
Mario Fadda, Enrico Giusto, Piero Saviozzi, *Appunti su un'antica strada savonese: via Pia*, «Atti della Società Savonese di Storia Patria», XXXI, 1959-1960, pp. 7–16

Falco, Gotta 1990
Maria Gilda Falco, Paolo Fabrizio
Gotta, *Palazzo della Rovere a Savona,
analisi storica, analisi tecnologica ed
ipotesi di fattibilità per un progetto di
recupero*, in *Analisi dell'architettura
costruita. 4 tesi di laurea della facoltà
di architettura su edifici storici liguri*, a
cura di Gianni V. Galliani, Brunetto De
Battè, Genova, Sagep, 1990, pp. 66–85

Falcone 2018
Maria Falcone, *Un altare eucaristico
in marmo per la cattedrale di
Genova*, in *Nelle terre del marmo.
Scultori e lapicidi da Nicola Pisano
a Michelangelo*, atti del convegno
(Pietrasanta-Seravezza, 12-13 dic.
2013), a cura di Aldo Galli, Antonio
Bartelletti, Pisa, Pacini editore, 2018,
pp. 83–115

Farris 1999
Giovanni Farris, *Compendio
cronologico dell'Istorie di Savona
(Copiato dal M.S. di Ottobono
Giordano Nt.o di Savona)*, a cura
di Giovanni Farris, Savona, Marco
Sabatelli Editore, 1999

Fehér 2010-2012
Ildikó Fehér, *Károly Pulszky
and the Florentine acquisitions
for the Szépművészeti Múzeum in
Budapest between 1893 and 1895*,
«Mitteilungen des Kunsthistorischen
Institutes in Florenz", 54, 2010-
2012, 2, pp. 319–364

Fernández 2007
Henry Dietrich Fernandez, *Piety
and Public Consumption. Domenico,
Girolamo and Julius II della Rovere at
Santa Maria del Popolo*, in *Patronage

and Dynasty: The Rise of the Della
Rovere in Reinassance Italy*, edited
by Ian Verstegen, Kirksville MO,
Truman State University Press, 2007,
pp. 39–58

Ferrajoli 1917
Alessandro Ferrajoli, *Il ruolo della
corte di Leone X* (Continuazione).
Prelati domestici, «Archivio della R.
Società Romana di Storia Patria», XL,
1917, 2, pp. 247–277

Filangieri 1950
Riccardo Filangieri, *Il codice miniato
della Confraternita di Santa Marta in
Napoli*, Milano, Electa, 1950

Filangieri di Candida 1947-1951
Riccardo Filangieri di Candida, *La
casa di Marino Marzano principe di
Rossano in Carinola*, in *Miscel·lània
Puig I Cadafalch. Recull d'estudis
d'arqueologia, d'història de l'art
i d'història oferts a Josep Puig i
Cadafalch per la Societat Catalana
d'estudis històrics*, 1, Barcelona,
Institut d'Estudis Catalans, 1947-
1951, pp. 37–40

Fiore 1979
Francesco Paolo Fiore, *Diffusione
e trasformazione del linguaggio
architettonico fiorentino: il palazzo
Della Rovere in Savona*, «Bollettino
del Centro Studi per la Storia
dell'architettura», 25, 1979,
pp. 23–30

Fiore 1989
Francesco Paolo Fiore, *La fabbrica
quattrocentesca del Palazzo Della
Rovere in Savona*, in *Sisto IV e Giulio
II mecenati e promotori di cultura*,

atti del convegno internazionale di
studi (Savona, 3-6 nov. 1985), a cura
di Silvia Bottaro, Anna Dagnino,
Giovanna Rotondi Terminiello,
Savona, Soprintendenza per i Beni
Artistici e Storici della Liguria-
Comune di Savona-Università degli
Studi di Genova-Coop Tipograf,
1989, pp. 261–276

Fiore 2002
Francesco Paolo Fiore, *Recherches en
histoire et formation des architectes.
L'exemple du palais Della Rovere
à Savone*, in *Méthodes en histoire
de l'architecture*, «Les cahiers de la
recherche architecturale et urbaine»,
9/10, 2002, pp. 113–126

Fiore 2017
Francesco Paolo Fiore, *Giuliano da
Sangallo e la facciata del palazzo
Della Rovere di Savona*, in *Giuliano
da Sangallo*, in *Giuliano da Sangallo*
(Firenze, data -Vicenza, 7-9 giu.
2012), a cura di Amedeo Belluzzi,
Caroline Elam, Francesco Paolo
Fiore, atlante fotografico di Václav
Šedý, Milano, Officina Libraria, 2017,
pp. 421–433

Folco 1991
Flavia Folco, *I portali del nostro
Centro storico, quelli del Savonese e
della Riviera di Ponente*, «Sabazia.
Quaderni di storia, arte, archeologia»,
n.s., 11, 1991, pp. 7–16

Forcella 1869
Vincenzo Forcella, *Iscrizioni delle
chiese e d'altri edificii di Roma dal
secolo XI fino ai giorni nostri*, I, Roma,
Tipografia delle Scienze Matematiche
e Fisiche, 1869,

Foschi 1994
Melozzo da Forlì. La sua città e il suo tempo, a cura di Marina Foschi, Milano, Leonardo Arte, 1994

Foster 1975
Philip Foster, *Renaissanceportale in Genua: Bemerkungen zu einem neuen Buch*, «Architectura», 2, 1975, pp. 178–186

Frapiccini 2001
David Frapiccini, *Il cardinale Girolamo Basso della Rovere e la sua cerchia tra contesti marchigiani e romani*, in *I Cardinali di Santa Romana Chiesa. Collezionisti e mecenati*, I, «Quasi oculi et aures ac nobilissimæ sacri capitis partes», a cura di Marco Gallo, Roma, Edizioni dell'Associazione Culturale Shakespeare & Company 2, 2001, pp. 9–23

Frapiccini 2013
David Frapiccini, *L'età aurea di Giulio II. Arti, cantieri e maestranze prima di Raffaello*, Roma, Gangemi Editore, 2013

Frommel 2014
Sabine Frommel, *Giuliano da Sangallo*, Firenze, Ente Cassa di Risparmio di Firenze-Edifir, 2014

Galli 2009
Aldo Galli, *Introduzione alla scultura di Castiglione Olona*, in *Lo specchio di Castiglione Olona. Il Palazzo del cardinale Branda e il suo contesto*, a cura di Alberto Bertoni, Varese, Edizioni Arterigere, 2009, pp. 54–73

Gallotti 2001
Giovanni Gallotti, *Le strade di Savona: vie, vicoli, piazze, corsi, la loro storia e quella dei loro nomi*, Savona, Punto e Linea, 2001

Gardelli 1993
Giuliana Gardelli, *Maiolica per l'architettura. Pavimenti e rivestimenti di Urbino e del suo territorio*, Urbino, 1993

Gardelli 2007
Giuliana Gardelli, *La Cappella Oliva di Montefiorentino. Araldica pavimentale: il primo esempio maiolicato del Rinascimento italiano*, in *Andrea Bregno, Giovanni Santi e la cultura adriatica del Rinascimento*, atti del convegno di studi (Urbino-Frontino, 24-25 giu. 2006), a cura di Giuliana Gardelli, Roma, Erreciemme, 2007, pp. 23–58

Garoni 1874
Nicolò Cesare Garoni, *Guida storica, economica e artistica della città di Savona compilata coi Documenti degli Archivi Municipali*, Savona, dai tipi di Gio. Sambolino, 1874

Gavazza 1959
Ezia Gavazza, *Ricerche sull'attività dei Gagini architetti a Genova*, in *Arte e artisti dei laghi lombardi*, a cura di Edoardo Arslan, 2 vols., Como, Noseda, 1959, I, pp. 173–184

Gavazza 1980
Ezia Gavazza, *Problemi per un rilevamento iconografico della scultura "decorativa" a Genova nel Rinascimento*, in *La scultura decorativa del Primo Rinascimento*,

atti del I convegno internazionale di studi (Pavia, 16-18 set. 1980), Roma, Viella, 1983, pp. 33–39

Giana 2002
Luca Giana, *Regione Piemonte. Schede storiche-territoriali dei comuni del Piemonte. Comune di Bistagno*, 2002, [online source: Regione Piemonte, consulted 2015]

Grimaldi 1986
Floriano Grimaldi, *La basilica della Santa Casa di Loreto. Indagini archeologiche, geognostiche e statiche*, Ancona, Soprintendenza per i Beni Ambientali e Architettonici delle Marche, 1986.

Gualdi 2009
Fausta Gualdi, *Pintoricchio e collaboratori nelle cappelle della navata destra*, in *Santa Maria del Popolo. Storia e restauri*, a cura di Ilaria Miarelli Mariani, Maria Richiello, 2 vols., Roma, Istituto Poligrafico e Zecca dello Stato. Libreria dello Stato, 2009, I, pp. 259–294

Guasco 1911
Francesco Guasco di Bisio, *Dizionario feudale degli antichi Stati Sardi e della Lombardia (dall'epoca carolingica ai nostri tempi, 774-1909)*, 5 vols., Pinerolo, Tipografia già Chiantore-Mascarelli, 1911 [online source: www.vivant.it/guasco/home_guasco.php, consulted 2018]

Guelfi Camaiani 1940
Piero Guelfi Camaiani, *Dizionario araldico*, Milano, Hoepli, 1940

Hasluck 1911
Frederick Williams Hasluck,

Genoese Lintel-Reliefs in Chios, «The Burlington Magazine for Connoisseurs», XVIII, 96, 1911, pp. 329–330

Howe 2005
Eunice D. Howe, *Art and culture at the Sistine Court: Platina's "Life of Sixtus IV" and the Frescoes of the Hospital of Santo Spirito*, Città del Vaticano, Biblioteca Apostolica Vaticana, 2005

Klapisch-Zuber 1969
Christiane Klapisch-Zuber, *Les maitres du marbre. Carrare 1300-1600*, Paris, S.E.V.P.E.N., 1969

Kruft 1971
Hanno-Walter Kruft, *Portali genovesi del Rinascimento*, Firenze, Edam Editrice, 1971

Kruft 1978
Hanno-Walter Kruft, *Alcuni portali genovesi del Rinascimento fuori Genova*, «Antichità viva. Rassegna d'arte», XVII, 6, 1978, pp. 31–35

Lavagna 2007
Rita Lavagna, *Indagini archeologiche nell'area della cattedrale medievale di Santa Maria Assunta (Savona complesso monumentale del Priamàr)*, «Ligures. Rivista di Archeologia, Storia, Arte e Cultura Ligure», 5, 2007, pp. 162–163

Lavagna 2009
Rita Lavagna, *Cattedrale di Savona al Priamàr: campagna di scavo 2009*, «Ligures. Rivista di Archeologia, Storia, Arte e Cultura Ligure», 7, 2009, pp. 195–196

Lavagna 2010
Rita Lavagna, *Indagini archeologiche nell'area della cattedrale di Santa Maria: Savona complesso monumentale del Priamàr; campagne di scavo 2007-2010*, «Ligures. Rivista di Archeologia, Storia, Arte e Cultura Ligure», 8, 2010, pp. 5–20

Lee 1979
Egmont Lee, *Iacopo Gherardi at the Court of Pope Sixtus IV*, «The Catholic Historical Review», LXV, 2, 1979, pp. 221–237

Leone de Castris 2002
Pierluigi Leone De Castris, *Il Codice di Santa Marta: miniatura e pittura nella Napoli angioina, aragonese e viceregnale*, «Napoli nobilissima», s. V, III, 2002, pp. 88–99

Lightbown 1961
Ronald W. Lightbown, *Three Genoese doorways*, «The Burlington Magazine», CIII, 703, 1961, pp. 412–417

Malandra 1974
Guido Malandra, *Documenti sulla Cappella Sistina e sul Palazzo Della Rovere a Savona*, «Atti e Memorie della Società Savonese di Storia Patria», n.s., VIII, 1974, pp. 135–141

Manno 1876
Antonio Manno, *Origini e vicende dello stemma Sabaudo*, in *Curiosità e ricerche di storia subalpina pubblicate da una società di studiosi di patrie memorie*, II, Roma-Torino-Firenze, Fratelli Bocca, 1876, pp. 270–328

Manno 1906
Antonio Manno, *Il Patriziato subalpino, notizie di fatto storiche, genealogiche, feudali ed araldiche, desunte da documenti*, II, *Dizionario genealogico, A-B*, Firenze, C. Civelli, 1906

Marchi 1993
Pietre di Liguria: materiali e tecniche dell'architettura storica, a cura di Paolo Marchi, testi critici e ricerche di Elena Cappellari *et alia*, Genova, Sagep Editrice, 1993

Mariotti 1925
Giovanni Mariotti, *L'arco di Parma in Roma e il Palazzo del Cardinale Parmense. A proposito di recenti pubblicazioni*, «Archivio Storico per le Province Parmensi», n.s., XXV, 1925, pp. 389–460

Massa Piergiovanni 1989
Paola Massa Piergiovanni, *Nuove ricerche sul Monte di Pietà di Savona*, in *L'età dei Della Rovere. Parte seconda*, atti del V Convegno storico savonese (Savona, 7-10 nov. 1985), «Atti e Memorie della Società Savonese di Storia Patria», n.s., XXV, 1989, pp. 147–152

Massa, Russo 1970-1971
Giovanni Massa, Alfonsino Russo, *Trasformazioni del centro urbano di Savona nell'Ottocento*, «Atti e Memorie della Società Savonese di Storia Patria», n.s., IV, 1970-1971, pp. 201–238

Massabò Ricci, Carassi, Gentile 1998
Blu, rosso e oro. Segni e colori dell'araldica in carte, codici e oggetti d'arte, a cura di Isabella Massabò Ricci, Marco Carassi, Luisa Clotilde

Gentile, catalogo della mostra (Torino, 29 set.-30 nov. 1998), Milano, Electa, 1998

Massucco 1970-1971
Rinaldo Massucco, *La Torre dello stendardo*, «Atti e Memorie della Società Savonese di Storia Patria», n.s., IV, 1970-1971, pp. 127–140

Massucco 1982
Rinaldo Massucco, *La Cattedrale di Santa Maria di Castello*, in Rinaldo Massucco, Marco Ricchebono, Tiziana Tassinari, Carlo Varaldo, *Il Priamàr prima pietra della storia bimillenaria di Savona. Dall'antico quartiere cittadino alla rinascimentale fortezza genovese. Un patrimonio storico, archeologico e monumentale da valorizzare*, Savona, Marco Sabatelli Editore, 1982, pp. 20–24

Massucco 1995
Rinaldo Massucco, *La vicenda del Priamàr nelle Cronache. La distruzione del quartiere di S. Maria e la costruzione della fortezza del Priamàr*, in *Giovanni Agostino Abate. Una fonte per la storia di Savona nel XVI secolo. Studi in occasione del quinto centenario della nascita (1495-1995)*, a cura di Claudio Paolocci, Ferdinando Molteni, Genova, Società Savonese di Storia Patria, 1995, pp. 155–160

Massucco 2014
Rinaldo Massucco, *Sisto IV e Giuliano della Rovere a Savona*, in *Sisto IV Giulio II papi savonesi*, Savona, Grafiche Fratelli Spirito, 2014, pp. 171–184

Massucco, Ricchebono, Tassinari, Varaldo 1982
Rinaldo Massucco, Marco Ricchebono, Tiziana Tassinari, Carlo Varaldo, *Il Priamàr prima pietra della storia bimillenaria di Savona. Dall'antico quartiere cittadino alla rinascimentale fortezza genovese. Un patrimonio storico, archeologico e monumentale da valorizzare*, Savona, Marco Sabatelli Editore, 1982

Massucco, Tassinari 1982
Rinaldo Massucco, Tiziana Tassinari, *La piazza della Cittadella e l'area archeologica della Cattedrale di N.S. di Castello*, in Rinaldo Massucco, Marco Ricchebono, Tiziana Tassinari, Carlo Varaldo, *Il Priamàr prima pietra della storia bimillenaria di Savona. Dall'antico quartiere cittadino alla rinascimentale fortezza genovese. Un patrimonio storico, archeologico e monumentale da valorizzare*, Savona, Marco Sabatelli Editore, 1982, pp. 125–132

Miarelli Mariani, Richiello 2009
Santa Maria del Popolo. Storia e restauri, a cura di Ilaria Miarelli Mariani, Maria Richiello, 2 vols., Roma, Istituto Poligrafico e Zecca dello Stato. Libreria dello Stato, 2009

Milazzo 1998
Giuseppe Milazzo, *Piazza delle Erbe. La storia dei Ciassé e dell'antico Palazzo di Giustizia di Savona*, Savona, Elio Ferraris Editore, 1998

Milazzo 2002
Giuseppe Milazzo, *La cappella di San Saturnino*, «Atti e Memorie della

Società Savonese di Storia Patria», n.s., XXXVIII, 2002, pp. 15–55

Milazzo 2009
Giuseppe Milazzo, *La statua del doge Della Rovere in piazza della Maddalena a Savona*, «Atti e Memorie della Società Savonese di Storia Patria», n.s., XLV, 2009, pp. 405–431

Miraglia 2011
Francesco Miraglia, *Palazzo Marzano a Carinola: i restauri degli anni trenta del Novecento*, «Civiltà Aurunca. Rivista trimestrale di cultura», XXVII, 84, 2011, pp. 43–62

Miretti 2004
Monica Miretti, *Il ducato di Sora e il potere dei roiereschi*, in *La Quercia dai frutti d'oro. Giovanni della Rovere (1457-1501) e le origini del potere roveresco*, atti del convegno di studi (Senigallia, 23-24 nov. 2001), a cura di Marinella Bonvini Mazzanti, Gilberto Piccinini, Ostra Vetere, Tecnostampa Edizioni, 2004, pp. 61–83

Monti 1697
Agostino Maria de' Monti, *Compendio di Memorie Historiche della Città di Savona e delle Memorie d'Huomini Illustri Savonesi*, Roma, stamperia di Marc'Antonio & Orazio Campana, 1697 [facsimile ed., Bologna, Forni, 1968]

Moretti 2004
Massimo Moretti, *Note storiche e storiografiche sulla ceramica pesarese del Quattrocento*, in *Maioliche del*

Quattrocento a Pesaro. Frammenti di Storia dell'arte ceramica della bottega dei Fedeli, Firenze, Centro Di, 2004, pp. 41–87

Müller Profumo 1992
Luciana Müller Profumo, Le pietre parlanti. L'ornamento nell'architettura genovese 1450-1600, Genova, Banca Carige-Cassa di Risparmio di Genova e Imperia, 1992

Müntz 1882
Eugène Müntz, Les arts à la cour des papes pendant le XV. et le XVI. siècle. Recueil de documents inédites tirés des archives et des bibliothèques romaines, III, Sixte IV – Léon X. 1471-1521. Première Section, Paris, Ernest Thorin, 1882

Musso 1995a
Riccardo Musso, L'arsenale sforzesco di Savona, in Studi in omaggio a Carlo Russo nel suo settantacinquesimo compleanno, Savona, Società Savonese di Storia Patria, 1995, pp. 285–294

Musso 1995b
Riccardo Musso, Ceto dirigente, fazioni ed istituzioni comunali della Savona rinascimentale, in Giovanni Agostino Abate. Una fonte per la storia di Savona nel XVI secolo. Studi in occasione del quinto centenario della nascita (1495-1995), a cura di Claudio Paolocci, Ferdinando Molteni, Genova, Società Savonese di Storia Patria, 1995, pp. 7–50

Musso 1998
Riccardo Musso, Lo "Stato cappellazzo". Genova tra Adorno e

Fregoso (1436-1464), «Studi di storia medievale e diplomatica», 17, 1998, pp. 223–286

Musso 2001
Riccardo Musso, "Viva el Duca et lo Sancto Padre". Savona al tempo degli Sforza e di Sisto IV (1464-1478), «Atti e Memorie della Società Savonese di Storia Patria», n.s., XXXVII, 2001, pp. 59–153

Mussolin 2013
Mauro Mussolin, Fiori di blasoneria. Gli stemmi di Sisto IV e Antonio Basso della Rovere d'Aragona nel sovrapporta di Villa La Pietra a Firenze, in Reinassance Studies in Honour of Joseph Connors, edited by Machtelt Israëls, Louis A. Waldman et alia, 2 vols., Milano, Officina Libraria, 2013, I, pp. 237–252

Nesi 2011
Museo Stefano Bardini. Guida alla visita del museo, a cura di Antonella Nesi, Firenze, Edizioni Polistampa, 2011

Nicolini 1980
Angelo Nicolini, Note d'archivio sulla topografia del Priamàr a metà del Quattrocento, «Atti e Memorie della Società Savonese di Storia Patria», n.s., XIV, 1980, pp. 73–83

Nicolini 1987
Angelo Nicolini, Topografia savonese antica. Note d'archivio (secoli XIV-XV). Parte I, «Sabazia. Quaderni di storia, arte, archeologia», n.s., 2, 1987, pp. 8–11

Nicolini 1988
Angelo Nicolini, Topografia savonese

antica. Note d'archivio (secoli XIV-XV). Parte II, «Sabazia. Quaderni di storia, arte, archeologia», n.s., 5, 1988, p. 10

Nicolini 2001
Angelo Nicolini, La gestione del porto di Savona fra Tre e Quattrocento, «Atti e Memorie della Società Savonese di Storia Patria», n.s., XXXVII, 2001, pp. 5–57

Nicolini 2009a
Angelo Nicolini, Il Priamàr, cinquant'anni dopo, «Atti e Memorie della Società Savonese di Storia Patria», n.s., XLV, 2009, pp. 199–269

Nicolini 2009b
Angelo Nicolini, Quattrocento savonese, «Atti della Società Ligure di Storia Patria», n.s., XLIX, 2009, 1, pp. 19–56

Nicolini 2009c
Appendice documentaria, a cura di Angelo Nicolini, in Giulio II e Savona, atti della sessione inaugurale del convegno Metafore di un pontificato. Giulio II (1503-1513) (Savona, 7 nov. 2008), a cura di Flavia Cantatore, Myriam Chiabò, Maurizio Gargano, Anna Modigliani, Roma, Roma nel Rinascimento, 2009, pp. 47–53

Nipoti di Sisto IV 1868
I nipoti di Sisto IV, «La Civiltà Cattolica», s. VII, a. XIX, vol. I, 1868, pp. 666–683

Noberasco 1917
Filippo Noberasco, La Cappella Sistina di Savona, «Arte e Storia», s. VI, a. XXXVI, 1917, 6/7, pp. 179–182

Noberasco 1923
Filippo Noberasco, *Le famiglie savonesi congiunte ai Della Rovere*, «Atti della Società Savonese di Storia Patria», VI, 1923, pp. 181–187

Noberasco, Scovazzi 1926-1928
Filippo Noberasco, Italo Scovazzi, *Storia di Savona*, 3 vols., Savona, Società Savonese di Storia Patria, 1926-1928

Noberasco, Scovazzi 1975
Filippo Noberasco, Italo Scovazzi, *Storia di Savona. Vicende di una vita bimillenaria*, nuova edizione riveduta e ampliata da Italo Scovazzi prima della morte e successivamente ordinata a cura di Nicolò Besio, 2 vols., Savona, Marco Sabatelli Editore, 1975

Olivieri 1999
Daniela Olivieri, *Savona*, Genova, Sagep, 1999

Paolocci, Molteni 1995
Giovanni Agostino Abate. Una fonte per la storia di Savona nel XVI secolo. Studi in occasione del quinto centenario della nascita (1495-1995), a cura di Claudio Paolocci, Ferdinando Molteni, Genova, Società Savonese di Storia Patria, 1995, pp. 69–80

Passaglia Bauman 2007
Lisa Passaglia Bauman, *Piety and Public consumption. Domenico, Girolamo and Julius II della Rovere at Santa Maria del Popolo*, in *Patronage and Dynasty: the rise of the Della Rovere in Reinassance Italy*, edited by Ian Verstegen, Kirksville MO,

Truman State University Press, 2007, pp. 39–58

Passerini, Litta 1863
Luigi Passerini, *Della Rovere di Savona, Duchi d'Urbino*, 7 tavv., in Pompeo Litta, *Famiglie celebri italiane*, Milano, Tipografia delle Famiglie Celebri Italiane, 1863, fascicolo 85, dispense 147, 151

Pastor 1900
Ludwig Pastor, *The History of the Popes, from the Close of the Middle Ages. Drawn from the Secret Archives of the Vatican and Other Original Sources*, IV, edited by Frederick Ignatius Antrobus, 1900, London, II ed.

Pastore 2002
Alessandro Pastore, *Giulio II papa*, in *Dizionario biografico degli italiani*, 57, Roma, Istituto dell'Enciclopedia Italiana Treccani, 2002, pp. 17–26

Pastoureau 1980
Michel Pastoureau, *L'origine suisse des armoiries du royaume d'Aragon: étude d'héraldique comparée*, «Archives héraldiques suisses», 94, 1980, pp. 3–10

Petrucci 1989
Franca Petrucci, *Della Rovere, Giovanni*, in *Dizionario biografico degli italiani*, 37, Roma, Istituto dell'Enciclopedia Italiana Treccani, 1989, pp. 347–350

Poggi P. 1936
Poggio Poggi, *Il Brandale. Storia della Torre del Brandale e dell'annesso Palazzo degli Anziani dalle origini ai nostri giorni*, «Atti della Regia

Deputazione di Storia Patria per la Liguria. Sezione di Savona», XVIII, 1936, pp. 31–88

Poggi P. 1938
Poggio Poggi, *Catalogo della Pinacoteca Civica di Savona*, Savona, Officina d'Arte, 1938

Poggi V., Poggi P. 1935
Vittorio Poggi, Poggio Poggi, *Cronotassi dei Principali Magistrati che ressero e amministrarono il Comune di Savona dalle origini alla perdita della sua autonomia. Parte IV (dal 1421-1470)*, «Atti della Società Savonese di Storia Patria», XVII, 1935, pp. 17–151

Poggi V., Poggi P. 1939
Vittorio Poggi, Poggio Poggi, *Cronotassi dei Principali Magistrati che ressero e amministrarono il Comune di Savona dalle origini alla perdita della sua autonomia. Parte V (dal 1471 al 1500)*, «Atti della Società Savonese di Storia Patria», XXI, 1939, pp. 3–126

Poggi V., Poggi P. 1940
Vittorio Poggi, Poggio Poggi, *Cronotassi dei Principali Magistrati che ressero e amministrarono il Comune di Savona dalle origini alla perdita della sua autonomia. Parte VI (dal 1501 al 1528)*, «Atti della Società Savonese di Storia Patria», XXII, 1940, pp. 3–155

Poleggi 1982
Ennio Poleggi, *Santa Maria di Castello e il romanico a Genova*, Genova, Sagep Editrice Genova, 1982, II ed.

Pöpper 2009
Thomas Pöpper, *Le opere di Andrea Bregno ed alcune opere di altri scultori*, in *Santa Maria del Popolo. Storia e restauri*, a cura di Ilaria Miarelli Mariani, Maria Richiello, 2 vols., Roma, Istituto Poligrafico e Zecca dello Stato. Libreria dello Stato, 2009, I, pp. 225–255

Quinterio [1990]
Francesco Quinterio, *Maiolica nell'architettura del Rinascimento italiano (1440-1520)*, Firenze, Cantini, s.d. [1990]

Renzulli 2002
Eva Renzulli, *Santa Maria di Loreto 1469-1535: Da baluardo cristiano a cappella pontificalis*, tesi di dottorato, XIV ciclo, tutor Howard Burns, Dipartimento di Storia dell'Architettura, Istituto Universitario di Architettura di Venezia, 2002

Ricchebono 1980
Marco Ricchebono, *Il Palazzo del Monte di Pietà. Un frammento di storia urbana savonese*, in *Savona nel Quattrocento e l'istituzione del Monte di Pietà*, a cura di Bruno Barbero, Giulio Fiaschini, Paola Massa, Marco Ricchebono, Carlo Varaldo, Savona, Cassa di Risparmio di Savona, 1980, pp. 331–370

Ricchebono, Varaldo 1982
Marco Ricchebono, Carlo Varaldo, *Savona*, Genova, Sagep Editrice, 1982

Robba 1990
Gianni Robba, *Disegno per una città, edilizia e architetture nei secoli XIV-XIX a Savona*, Genova, Grafica KC, 1990

Rocca 1872
Giuseppe Andrea Rocca, *Le chiese e gli spedali della Città di Savona non più esistenti o che subirono modificazioni*, Lucca, B. Canovetti, 1872

Rosi 1979
Massimo Rosi, *Il palazzo Marzano di Carinola*, Napoli, Regina, 1979

Rossi 1876-1877
Girolamo Rossi, *Della Rovere di Savona*, «Giornale araldico-genealogico-diplomatico», IV, 1876-1877, pp. 323–326

Rossi 1995
Simonetta Rossi, *Giovanni Agostino Abate tra memoria e cronaca: note per una biografia*, in *Giovanni Agostino Abate. Una fonte per la storia di Savona nel XVI secolo. Studi in occasione del quinto centenario della nascita (1495-1995)*, a cura di Claudio Paolocci, Ferdinando Molteni, Genova, Società Savonese di Storia Patria, 1995, pp. 51–68

Rossini 1979
Giorgio Rossini, *Architettura di palazzo ed architettura di villa a Savona fra Cinque e Seicento*, in *Arte a Savona nel Seicento. Parte seconda*, atti del III convegno storico savonese (Savona, 29-30 apr. 1978), 2 vols., «Atti e Memorie della Società Savonese di Storia Patria», n.s., XIII, 1979, II, pp. 97–120

Rossini 1989
Giorgio Rossini, *La "Cappella del Papa" presso il Convento di S. Francesco: compresenze di motivi lombardi e toscani a Savona nella seconda metà del Quattrocento*, in *Sisto IV e Giulio II mecenati e promotori di cultura*, atti del convegno internazionale di studi (Savona, 3-6 nov. 1985), a cura di Silvia Bottaro, Anna Dagnino, Giovanna Rotondi Terminiello, Savona, Soprintendenza per i Beni Artistici e Storici della Liguria-Comune di Savona-Università degli Studi di Genova-Coop Tipograf, 1989, pp. 277–289

Rossini 2000
Giorgio Rossini, *La Cappella Sistina di Savona. Architettura francescana e mecenatismo roveresco, con contributi di approfondimento di Giovanna Rotondi Terminiello e Maurizio Tarrini*, Savona, Marco Sabatelli Editore, 2000

Rossini 2002
Giorgio Rossini, *La Chiesa e il Convento di San Francesco*, in *Un'isola di devozione a Savona. Il complesso monumentale della Cattedrale dell'Assunta. Duomo, Cappella Sistina, Palazzo Vescovile, Oratorio di N.S. di Castello*, a cura di Giovanna Rotondi Terminiello, Savona, Marco Sabatelli Editore, 2002, pp. 119–141

Rossini 2009
Giorgio Rossini, *Le architetture dei Della Rovere in Liguria. La Cappella Sistina di Savona e i palazzi di Genova*, in *Giulio II e Savona* atti della sessione inaugurale del

convegno *Metafore di un pontificato. Giulio II (1503-1513)* (Savona, 7 nov. 2008), a cura di Flavia Cantatore, Myriam Chiabò, Maurizio Gargano, Anna Modigliani, Roma, Roma nel Rinascimento 2009, pp. 55–74

Rotondi 1989
Pasquale Rotondi, *Sul progetto del monumento sepolcrale dei genitori di Sisto IV (Un'ipotesi di lavoro)*, in *Sisto IV e Giulio II mecenati e promotori di cultura*, atti del convegno internazionale di studi (Savona, 3-6 nov. 1985), a cura di Silvia Bottaro, Anna Dagnino, Giovanna Rotondi Terminiello, Savona, Soprintendenza per i Beni Artistici e Storici della Liguria-Comune di Savona-Università degli Studi di Genova-Coop Tipograf, 1989, pp. 291–295

Rotondi, Rotondi Terminiello 2002
Pasquale Rotondi, Giovanna Rotondi Terminiello, *Capella Sisti, olim pape quarti, sita in monasterio sancti Francisci de Savona*, in *Un'isola di devozione a Savona. Il complesso monumentale della Cattedrale dell'Assunta. Duomo, Cappella Sistina, Palazzo Vescovile, Oratorio di N.S. di Castello*, a cura di Giovanna Rotondi Terminiello, Savona, Marco Sabatelli Editore, 2002, pp. 143–141

Rotondi Terminiello 2002
Un'isola di devozione a Savona. Il complesso monumentale della Cattedrale dell'Assunta. Duomo, Cappella Sistina, Palazzo Vescovile, Oratorio di N.S. di Castello, a cura di Giovanna Rotondi Terminiello, Savona, Marco Sabatelli Editore, 2002

Rotondi Terminiello 2004
Giovanna Rotondi Terminiello, *Le origini savonesi della dinastia roveresca: committenza in patria dei papi Della Rovere*, in *I Della Rovere, Piero della Francesca, Raffaello, Tiziano*, catalogo della mostra (Senigallia-Urbino-Pesaro-Urbania, 4 apr.-3 ott. 2004), a cura di Paolo Dal Poggetto, Milano, Electa, 2004, pp. 113–116

Rotondi Terminiello, Balma, Ferraris 2005
Giovanna Rotondi Terminiello, Giorgio Balma, Michele Ferraris, *Modello ligneo della Cappella Sistina di Savona*, in *Giulio II papa, politico, mecenate*, atti del convegno (Savona, 25-27 mar. 2004), a cura di Giovanna Rotondi Terminiello, Giulio Nepi, Genova, De Ferrari Editore, 2005, pp. 24–26

Russo 1936
Martino Nicolò Russo, *Contributo alla storia del Comune di Savona. Documenti inediti circa il Brandale e annessi edifici comunali*, «Atti della Regia Deputazione di Storia Patria per la Liguria. Sezione di Savona», XVIII, 1936, pp. 5–30

Ruysschaert 1984
José Ruysschaert, *Les trois étapes de laménagement de la Bibliothèque Vaticane de 1471 à 1481*, in *Un pontificato ed una città: Sisto IV (1471-1484)*, atti del convegno (Roma, 3-7 dic. 1984), a cura di Massimo Miglio, Francesca Niutta, Diego Quaglioni, Concetta Ranieri, Roma, Istituto Storico Italiano per il Medio Evo, 1986, pp. 103–114

Ruysschaert 1989
José Ruysschaert, *Sixte IV fondateur de la Bibliotèque Vaticane et la fresque restaurée de Melozzo da Forlì (1471-1481)*, in *Sisto IV e Giulio II mecenati e promotori di cultura*, atti del convegno internazionale di studi (Savona, 3-6 nov. 1985), a cura di Silvia Bottaro, Anna Dagnino, Giovanna Rotondi Terminiello, Savona, Soprintendenza per i Beni Artistici e Storici della Liguria-Comune di Savona-Università degli Studi di Genova-Coop Tipograf, 1989, pp. 27–44

Ruysschaert 1990
José Ruysschaert, *La fresque de Melozzo da Forlì de l'ancienne Bibliothèque Vaticane. Réexamen*, «Miscellanea Bibliothecae Apostolicae Vaticanae», IV, 1, 1990, pp. 329–341

Sardina 2008
Patrizia Sardina, *Marzano, Marino*, in *Dizionario biografico degli italiani*, 71, Roma, Istituto dell'Enciclopedia Italiana Treccani, 2008, pp. 446–450

Savio 1890-1891
Fedele Savio, *Della Rovere di Savona*, «Giornale araldico-genealogico-diplomatico», XVIII, 1890-1891, pp. 1–12

Savorelli 1999
Alessandro Savorelli, *L'origine dello stemma di Napoli tra arte, storia e mito*, «Napoli nobilissima: rivista di topografia ed arte napoletana», s. IV, XXXVIII, 1999, pp. 185–194

Scarrone 1970-1971
Mario Scarrone, *Chiese della*

città e diocesi di Savona nel 1530. Manoscritto Zuccarello, «Atti e Memorie della Società Savonese di Storia Patria», n.s., IV, 1970-1971, pp. 296–305

Schmarsow 1886
August Schmarsow, *Melozzo da Forli: ein Beitrag zur Kunst-und Kulturgeschichte Italiens im XV. Jahrhundert*, Berlin, Speeman, 1886

Schottmüller 1922
Frida Schottmüller, *Die Italienischen Möbel und Dekorativen Bildwerke Kaiser Friedrich*, Stuttgart, Verlag von Julius Hoffmann, 1922

Scovazzi 1932
Italo Scovazzi, *Origini. Miti e leggende Liguri e Piemontesi*, «Atti della Società Savonese di Storia Patria», XIV, 1932, pp. 53–208

Scovazzi, Besio 1959
Italo Scovazzi, Giovanni Battista Nicolò Besio, *Il Priamàr dal secolo XI al XVI*, in *Il Priamàr*, «Atti della Società Savonese di Storia Patria», XXX, 1959, pp. 25–55

Shearman 1977
John W. Shearman, *Raphael, Rome and the Codex Escurialensis*, «Master Drawings», 15, 1977, pp. 107–146

Shearman 2003
John Shearman, *Raphael in Early Modern Sources (1483-1602)*, 2 vols., New Haven-London, Yale University Press, 2003

Simoncini 2004
Roma. Le trasformazioni urbane nel Quattrocento, a cura di Giorgio Simoncini, 2 vols., Firenze, Leo S. Olschki Editore, 2004

Sommario de documenti 1727
Sommario de Documenti Che giustificano Il supremo, & alto Dominio della Santa Sede Sopra de Feudi Ecclesiastici in Piemonte, Romae, Typis R. Cam. Apostolicae, 1727

Sperindei 2004
Simona Sperindei, *Repertorio delle residenze cardinalizie*, in *Roma. Le trasformazioni urbane nel Quattrocento, II, Funzioni urbane e tipologie edilizie* a cura di Giorgio Simoncini, Firenze, Leo S. Olschki Editore, 2004, pp. 137–158

Suida 1906
Wilhem Suida, *Genua*, Leipzig, Verlag von E.U. Seeman, 1906

Tagliaferro 1986
Laura Tagliaferro, *D'Aria*, in *Dizionario biografico degli italiani*, 32, Roma, Istituto dell'Enciclopedia Italiana Treccani, 1986, pp. 782–787

Tagliaferro 1987
Laura Tagliaferro, *Un secolo di marmo e di pietra: il Quattrocento*, in *La scultura a Genova e in Liguria dalle origini al Cinquecento*, Genova, Cassa di Risparmio di Genova e Imperia, 1987, pp. 215–250

Teodori 2003a
Raissa Teodori, *Grosso della Rovere, Clemente*, in *Dizionario biografico degli italiani*, 60, Roma, Istituto dell'Enciclopedia Italiana Treccani, 2003, pp. 13–14

Teodori 2003b
Raissa Teodori, *Grosso della Rovere, Leonardo*, in *Dizionario biografico degli italiani*, 60, Roma, Istituto dell'Enciclopedia Italiana Treccani, 2003, pp. 14–17

Testa 2006
Fausto Testa, «Che 'l Tiber per veder scoperse il collo. E pargli quasi il suo tempo ritorni». *La rinascita di Roma antica e la retorica politica pontificia nel trionfo di Giulio II per il carnevale del 1513*, in *Das alte Rom und die neue Zeit*, hrsg von Martin Disselkamp, Peter Ihring, Friedrich Wolfzettel, Tübingen, Narr, 2006, pp. 91–151

Torteroli 1847
Tommaso Torteroli, *Monumenti di pittura, scultura e architettura della città di Savona*, Savona, Prudente, 1847

Toscano 1998
La miniatura a Napoli: da Renato d'Angiò ad Alfonso il Magnanimo, in *La Biblioteca Reale di Napoli al tempo della dinastia Aragonese*, catalogo della mostra (Napoli, 30 set.-15 dic. 1998), a cura di Gennaro Toscano, Valencia, La Imprenta, 1998, pp. 323–381

Tosi 1856
Francesco Maria Tosi, *Raccolta di monumenti sacri e sepolcrali scolpiti in Roma nei secoli XV e XVI, misurati e disegnati dallo architetto cav.r Francesco M.a Tosi ed a contorno intagliati in rame da valenti artisti* [...], V, [Roma], presso l'editore proprietario, 1856

Tumidei 1992
Stefano Tumidei, recensione a José Ruysschaert (*La fresque de Melozzo da Forlì de l'ancienne Bibliothèque Vaticane*. *Réexamen*, «Miscellanea Bibliothecae Apostolicae Vaticanae», IV, 1, 1990, pp. 329-341), «Roma nel Rinascimento», 1992, pp. 308–309

Valeriano 1620
Pierio Valeriano, *De Litteratorum Infelicitate*, Venetjis, apud Jacobum Sarzinam, 1620

Varaldo 1974
Carlo Varaldo, *I D'Aria e i mausolei «rovereschi» nella Savona rinascimentale*, «Atti e Memorie della Società Savonese di Storia Patria», n.s., VIII, 1974, pp. 143–154

Varaldo 1975
Carlo Varaldo, *La topografia urbana di Savona nel tardo Medioevo*, Bordighera, Istituto Internazionale di studi liguri, 1975

Varaldo 1977
Carlo Varaldo, *La storia di Savona nell'evoluzione della sua topografia urbana*, «Savona economica. Periodico della Camera di Commercio di Savona», n.s., IX, 3, 1977, pp. 99–105

Varaldo 1978
Corpus inscriptionum Medii Aevi Liguriae, I, *Savona-Vado-Quiliano*, a cura di Carlo Varaldo, Genova, Istituto di Paleografia e di Storia Medioevale, 1978

Varaldo 1980
Carlo Varaldo, *Savona nel secondo Quattrocento. Aspetti di vita economica e sociale*, in *Savona nel Quattrocento e l'istituzione del Monte di Pietà*, a cura di Bruno Barbero, Giulio Fiaschini, Paola Massa, Marco Ricchebono, Carlo Varaldo, Savona, Cassa di Risparmio di Savona, 1980, pp. 7–163

Varaldo 1983
Carlo Varaldo, *Appunti sui ceti dirigenti nella Savona del secondo Quattrocento*, in *La storia dei Genovesi*, III, atti del convegno di studi sui ceti dirigenti nelle istituzioni della Repubblica di Genova (Genova, 10-12 giu. 1982), Genova, Copy-lito, 1983, pp. 131–141

Varaldo 1985
Carlo Varaldo, *Economia e società a Savona nella seconda metà del Quattrocento*, «Sabazia. Quaderni di storia, arte, archeologia», n.s., 8, 1985, pp. 3–12

Varaldo 1992
Archeologia urbana a Savona scavi e ricerche nel complesso monumentale del Priamàr, a cura di Carlo Varaldo, 3 vols., Bordighera, Istituto Internazionale di studi liguri, 1992

Varaldo 1995
Carlo Varaldo, *I tesori d'arte del centro storico di Savona*, Savona, Marco Sabatelli Editori, 1995

Varaldo 2002
Carlo Varaldo, *La cattedrale del Priamàr: un monumento perduto*, in *Un'isola di devozione a Savona. Il complesso monumentale della Cattedrale dell'Assunta. Duomo*, *Cappella Sistina, Palazzo Vescovile, Oratorio di Nostra Signora di Castello*, a cura di Giovanna Rotondi Terminiello, Savona, Marco Sabatelli Editori, 2002, pp. 21–56

Varaldo O. 1888a
Ottavio Varaldo, *Sulla famiglia Della Rovere. Appendice al discorso*, «Atti e Memorie della Società Storica Savonese», I, 1888, pp. XCVII– CIV

Varaldo O. 1888b
Ottavio Varaldo, *Compendio della casa Della Rovere di Bernardino Baldi*, «Atti e Memorie della Società Storica Savonese», I, 1888, pp. 409–430

Varaldo O. 1889
Ottavio Varaldo, *Le tarsie del coro del duomo di Savona*, «Atti e Memorie della Società Storica Savonese», II, 1889, pp. 41–51

Venturi 1924
Adolfo Venturi, *Storia dell'arte italiana*, VIII, *L'architettura del Quattrocento. Parte seconda*, Milano, Ulrico Hoepli, 1924

Venturino 2007
Gianni Venturino, *La cattedrale scomparsa*, Cosseria-Savona, Grafiche Fratelli Spirito, 2007

Verstegen 2007
Patronage and Dynasty: the rise of the Della Rovere in Reinassance Italy, edited by Ian Verstegen, Kirksville MO, Truman State University Press, 2007

Verzellino ed. Astengo 1885-1891
Giovanni Vincenzo Verzellino, *Delle*

memorie particolari e specialmente
degli uomini illustri della città di
Savona, a cura di Andrea Astengo, 2
vols., Savona, Domenico Bertolotto e
C., 1885-1891

Villani 2006
Manuela Villani, *Scultori lombardi*
a Savona nella seconda metà del
Quattrocento: alcune riflessioni e
qualche proposta, «Ligures. Rivista
di Archeologia, Storia, Arte e Cultura
Ligure», 4, 2006, pp. 87–116

Villani 2007
Manuela Villani, *«Pichapietra»*
lombardi a Savona tra Quattro e
Cinquecento: Matteo da Bissone
e Gabriele da Cannero, «Arte
Lombarda», n.s., 150, 2007, 2,
pp. 35–50

Villeneuve 1887
Léonce de Villeneuve, *Recherches*
sur la famille Della Rovere:
contribution pour servir à l'histoire
du Pape Jules II, Rome, Imprimerie
A. Befani, 1887

Vivaldo 1970-1971
Lorenzo Vivaldo, *La descrizione*
dell'antico Duomo di Savona in un
documento dell'Archivio Vescovile,
«Atti e Memorie della Società
Savonese di Storia Patria», n.s., IV,
1970-1971, pp. 306–308

Weber 1999
Christoph Weber, *Päpste und*
Papsttum, XXIX/1, *Genealogien zur*
Papstgeschichte, unter Mitwirkung
von Michael Becker, Bearbeitet von
Christoph Weber, Stuttgart, Anton
Hiersemann, 1999

Zazzera 1615
Francesco Zazzera, *Della Nobiltà*
dell'Italia. Parte Prima, in Napoli per
Gio.Battista Gargano, & Lucretio
Nucci, 1615

Zurla 2014
Michela Zurla, *La scultura a Genova*
tra XV e XVI secolo. Artisti, cantieri
e committenti, tesi di dottorato,
XXVII ciclo, tutor Aldo Galli, Scuola
di Dottorato in Studi Umanistici,
Dipartimento di Lettere e Filosofia,
Università di Trento, 2014

Photograph Credits

Author: 1, 4, 5, 6, 11, 13, 15, 16, 21,
22, 23, 24, 25, 26, 27, 28, 29, 30, 31,
32, 33, 34, 35, 36, 38, 39, 41, 43, 44,
46, 47, 49, 50, 53, 55,

Archivio di Stato di Genova: 20

Archivio di Stato di Napoli: 7, 12

Archivio di Stato di Savona: 8, 51,
52, 54

Isabella Stewart Gardner Museum,
Boston: 40, 42

The Acton Photograph Archive,
Villa La Pietra, NYU Florence: 2, 3

The digital reconstruction of the
Basso Della Rovere d'Aragona portal,
city plans of Savona in the 15th
century, and the genealogy of the
Della Rovere are by Leonardo Pili and
Mauro Mussolin

Printed in Italy
ex officina libraria Jellinek et Gallerani